KB100314

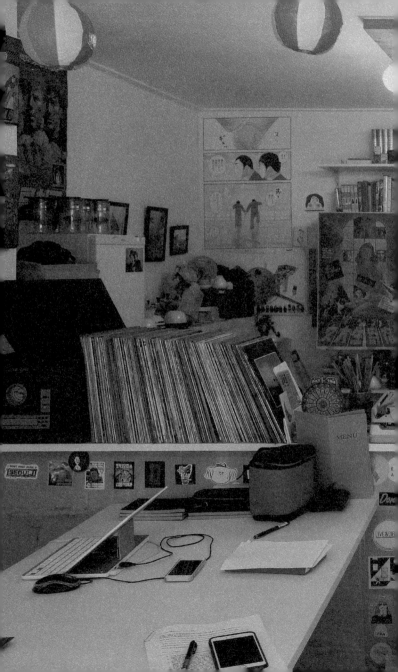

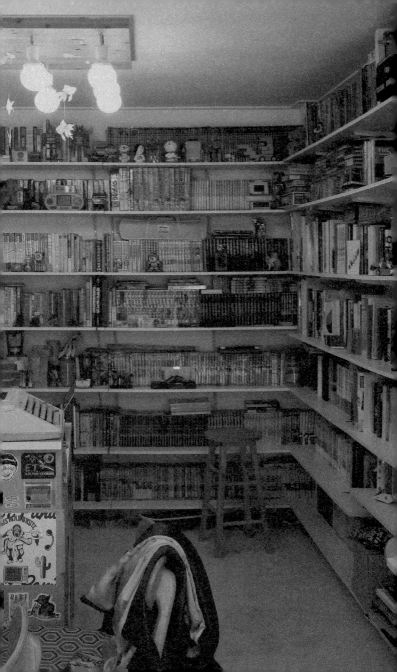

BB2

브레멘에서 바젤까지
From Bremen to Basel

BB2

브레멘에서 바젤까지
From Bremen to Basel

곽은정	Kwak Eunjung
신가을	Shin Ga-Eul
알렉스	Lee Alex
이지연	Lee Ji-Yeon

서문

『BB2: 브레멘에서 바젤까지』는 2016년 6월 8일 독립출판을
주제로 스위스와 독일에서 이루어진 파주타이포그라피학교
(이하 파티) 정규 수업 '길 위의 멋짓'을 바탕으로 하고 있다.
8박 9일 동안 브레멘과 베를린을 거쳐 바젤에서 마무리된
이 여행은, 매년 열리는 스위스와 독일의 아트북페어 시기에
맞춰 기획되었다. 여행의 출발지와 종착지의 머리글자를 합친
'BB' 그리고 길 위의 멋짓 두 번째 출판물을 의미하는 '2'를
더해 'BB2 프로젝트'라는 이름으로 진행되었다. 이를 위해
꾸려진 인원은 총 6명으로, 기획자 및 인솔교사 역할을
맡은 알렉스와 곽은정을 포함한 4명의 파티 배우미 ─ 더배곳의
이지연과 윤지원, 한배곳의 신가을 그리고 휴학 중인 최진훈 ─
가 여정에 올랐다. 교실이 아닌 길 위에서의 만남을 통해
독립출판물의 생태를 익히고 그 경험을 출판물의 형태로 기록
하는 것이 목표였다.

책은 크게 인터뷰, 워크숍, 아트북페어로 구성되어있다.
인터뷰는 독립출판과 직간접적으로 관련된 각기 다른 분야의
사람들 ─ 1인 잡지 제작자, 서점 운영자, 디자이너, 독립출판
프로젝트 일원, 작가, 아티스트북 수집가 그리고 아트북페어
기획자 ─ 과 진행했으며, 그 내용은 12개의 키워드로
재구성되었다. 워크숍은 브레멘예술대학의 출판 동아리인
'프레시 프린트'와 바젤디자인학교 재학생 아나 브랑코빅과

함께했다. 그 협업의 결과물은 세 학교-브레멘예술대학, 바젤디자인학교, 파티-학생들의 책과 함께 바젤의 '아이 네버 리드' 아트북페어에 먼저 소개된 후, 2016년 11월 서울의 '언리미티드 에디션' 아트북 페어에 선보였다. 이 일련의 과정은 당일 워크숍 경험을 반영한 글과 페어에 대한 설명 및 전시 물품을 서술한 글로 나누어 묘사했다. 각각의 글 사이에 시간순 으로 나열된 사진은 대화와 협업 그리고 유통으로 이어지는 여정의 전반적인 흐름을 보여준다.

BB2 프로젝트의 시작은 독립출판이었으나, 이를 주제로 파생한 결과물은 더 넓은 의미로서의 책의 역할과 그 가능성을 질문한다. 책은 기록 혹은 정보 전달의 수단으로, 아름다운 소장품으로, 때론 개성의 발화로 여겨진다. 변화하는 책의 속성을 탐구하며, 우리 또한 이 책이 다채로운 성격을 지닌 열린 매개체가 되길 바라는 마음으로 제작에 임했다. 어쩌면 이 책은 우리에게 독립출판이라는 테두리 안에서 국경의 경계 없이 서로의 의견을 주고받을 수 있는 헤테로토피아적 공간을 열어준 열쇠였을지도 모른다. 비록 그 찰나의 경험을 직접 공유할 수는 없지만, 그 기록의 일부인 『BB2: 브레멘에서 바젤까지』를 통해 이 책을 접하는 독자들에게 책이라는 매체가 단순히 '읽는 대상'이 아닌, 공감, 교류 혹은 새로운 만남을 제공하는 또 다른 통로로 작용하길 바란다. 그리고 무엇보다 이 책을 계기로 앞으로의 '길 위의 멋짓'이 일시적인 여행이 아닌, 배우 미 스스로 주체적인 이야기를 만들고 공유할 수 있는 경험의 장으로 거듭나길 바란다.

끝으로 이 책이 완성되기까지 많은 분의 도움이 있었다. 먼저 열린 마음으로 프로젝트에 동참하고 의견을 공유해준 고성배, 마누엘 레더, 바바라 빈, 베티나 브라흐, 아나 브랑코빅, 이로, 이리 옵라텍, 읻다의 최성웅, 김보미, 전가경, 타니아 프릴, 테드 데이비스, 파얌 샤리피, 파트라 그라프, 프레시 프린트 학생 그룹, 현영석, 바젤 아트북페어 참여를 도와주신 바젤 디자인학교의 마이클 레너와 안진수 님, 바젤에 머무는 동안 따뜻한 숙소를 마련해준 카트리나 아메타이, 이번 기획을 믿고 지켜봐주신 파티 날개 안상수 님과 공모 지원 사업에 도움을 주신 정실 그리고 책 마무리에 힘을 써준 박하얀, 요아힘 뮬러-랑세, 최문경 님에게 이 자리를 빌려 깊은 고마움을 전한다.

2017년 8월
알렉스

Editorial

"BB2: From Bremen to Basel" was created on the basis of the Paju Typography Institute (PaTI)'s regular class curriculum, 'Design on the Road', which took place in three cities of Switzerland and Germany within the theme of "independent publishing". The 8-night / 9-day trip, beginning in Bremen, then going to Berlin and Basel, was planned according to the opening date of the annual art book fairs happening in Switzerland and Germany. Combining 'BB', the first letters of the starting and ending location of the trip, with '2', indicating the second publication of 'Design on the Road', the journey was named the "BB2 project". Altogether there were six people on board for the trip: Lee Alex and Kwak Eunjung, project co-directors who were also in charge of guiding the travel, and four PaTI students – Lee Ji-yeon and Yoon Ji-won from the postgraduate program, Shin Ga-eul from the undergraduate program and Choi Jin-hoon who was temporarily absent from the school. Across the classroom, taking encounters made during the trip as an opportunity to explore the microcosm of independent publications, and in the end, documenting its experience as a form of publication – were the main goal.

The book itself was at large composed of three parts: interviews, workshops, and art book fairs. The Interviews were conducted individually with people from various professional fields – self-publishers, bookshop owners, independent book project members, writers, artist book collectors and book fair hosts – who were either directly or indirectly connected to the subject of independent publishing. The contents provided by the interviewees were later dissected and recomposed under 12 different keywords. For the workshops, two collaborations were conducted firstly with "Fresh Prints", a publishing platform at the University of the Arts Bremen, and secondly with Ana Brankovic who was a student of the Basel School of Design at the time. The results of the collaborations were initially presented at "I Never Read", an art book fair in Basel, and then in Seoul's "Unlimited Edition" in November of 2016. In the book, these series of events were documented as two types of writing in which one presents the reflections of the workshop experiences and the other, general information about the book fairs as well as descriptions of the displayed objects. The chronological images inserted between the writings capture the big picture of the journey where conversations and collaborations extend to the sites of distribution.

Though the BB2 project initiated with the theme of "independent publishing", the outcome branched out of this topic in the end, heading toward a broader question – what are the potentials and possible roles of books? Books are indeed considered as a means to convey information, as beautiful objects and sometimes as ignitions of one's individuality. While delving into its diversified properties, we also wished this book to be an open medium which can be approached from multiple perspectives. Perhaps for us, this book was a key to an instant heterotopia where mixed ideas about independent publishing had been freely transmitted beyond cultural boundaries. Although these experiences can't be shared in an exact manner, through "BB2: From Bremen to Basel", we wish the readers may perceive books not only as readable objects but also a threshold for sympathy, exchange, and new encounters. Above all, we also wish this book to be a good precedent for PaTI students to consider 'Design on the Road' not as an ephemeral experience but rather a platform to build and share their own stories.

Lastly, there were numerous people who helped bring this to publication. Those who welcomed our visit and shared their opinions with open hearts: Ana Brankovic, Barbara Wien, Bettina Brach, Fresh Prints, Hyun Young-seok, Iro, Itta (Choi Sung-woong and Kim Bomi), Jeon Ga-gyeong, Jiri Oplatek, Koh Sung-bae, Manuel Raeder, Patra Graph, Payam Sharifi, Tania Prill and Ted Davis; Professors Ahn Jin-soo and Michael Renner of the Basel School of Design who supported our participation at I Never Read; Katrina Ahmetaj who gladly offered us accommodation during our stay in Basel; Prof. Ahn Sang-soo who approved and encouraged the project; Jung Sil who helped us manage the project funding process; Choi Moon-kyung, Joachim Müller-Lancé and Park Ha-yan who spared their time for the publication of the book. I would like to express the deepest thanks to all these people.

August 2017
Alex Lee

차례

Table of Contents

사람들

고성배

2014년에 발간을 시작한 1인 독립잡지 『The Kooh』의 편집자. 복고풍 책다방 '홀리데이 아방궁'을 운영한다.

마누엘 레더

베를린에 살며 소규모 스튜디오를 운영하는 디자이너. 런던 칼리지 오브 프린팅에서 공부한 후, 얀 반 에이크 아카데미에서 대학원 과정을 수료했다. 2003년 베를린과 멕시코 시티에 기반을 둔 '스튜디오 마누엘 레더'를 설립했으며, 2011년에는 '봄 디아 보아 타르데 보아 노이테' 출판사를 열었다. 예술가, 디자이너, 이론가, 음악가, 큐레이터와의 협업에 주안점을 두며 전시, 책, 편집, 출판, 서체디자인, 가구 디자인과 같은 다양한 매체를 넘나드는 작업을 한다.

바바라 빈

독일의 아티스트북 수집가, 출판인 겸 미술관 운영자. 프라이부르크 알베르트루트 비히대학교와 베를린자유대학교에서 문학과 역사학을 전공했다. 이후 베를린에서 예술 평론가, 편집자로 일하며 디터 로스, 백남준, 귄터 브루스, 구보타 시게코, 헤르만 니취와 같은 예술가에 대한 인터뷰와 기사를 출판했다. 1988년, 갤러리와 60년대 이후 아티스트 북을 다룬 서점이 함께 있는 출판사 '빈 프레스'를 설립했다. 2013년부터는 양혜규, 조지 브레히트, 토마스 슈미트와 같은 예술가가 기고한 『글 쓰는 법』 시리즈를 기획 및 출판하고 있다.

베티나 브라흐

브레멘 베저부르크 박물관에 위치한 '아티스트 퍼블리케이션 센터'의 큐레이터. 전시를 포함해 수집품 관리와 연구자 안내를 돕는다.

전가경

이화여자대학교와 서울대학교 대학원에서 문학을, 홍익대학교 대학원에서 시각
디자인을 전공했다. 졸업 후 디자인 스튜디오 'AGI 소사이어티'에서 출판팀장
으로 일했다. 홍익대학교 석사 논문 『텍스트로서의 사진과 이미지로서의 사회:
'트웬 Twen'의 사진 다루기』(2006)를 시작으로 '사진 - 텍스트 - 디자인'이라는
매개항에 관심을 두고 연구하고 있다. 현재 정재완과 함께 운영하고 있는 사진
책 출판사 '사월의눈'은 이런 관심사의 연장이다. 2013년 출판한 『사이에서』를
기점으로 지금까지 총 6권의 책을 기획했으며, 다수의 매체에 그래픽 디자인 관련
글을 기고했다.

아나 브랑코빅

스위스 바젤의 문화, 사회, 출판과 관련된 작업을 하는 디자이너이자 기획자. 바젤
대학교에서 미디어 과학과 경제학을 공부하고 바젤디자인학교에서 시각 소통과
아이코닉 연구 석사과정을 이수했다. 바젤의 지역 정보를 다룬 '비 베어스 말 밋'
온라인 사이트를 공동 창립한 그녀는 현재 바젤 펠트베르크 거리를 기반으로 둔
하이퍼로컬 저널리즘 및 출판에 관한 잡지를 제작하고 있다.

이로

2009년부터 책방 '유어마인드'와 서울 아트북페어 『언리미티드 에디션』을 운영
하고 있으며, 2012년 동명의 출판사를 만들어 젊은 작가들의 작업을 책으로
엮고 있다. 저서로 『위트 그리고 디자인』(공저, 지콜론, 2013), 『책등에 베이다』
(이봄, 2014), 『16시: 선명한 유령』(안그라픽스, 2014)이 있고 2017년에 나올
새 책을 쓰고 있다.

이리 옵라텍

바젤디자인학교 학생을 지도하며 디자인 스튜디오를 운영한다. 2003년 롤란드 존,
토마스 비쳐와 함께 '클라우디아 바젤'을 공동 설립한 후 독자적인 프로젝트를
주로 진행했다. 문화 기관과 연계된 작업 중에는 바젤의 건축 박물관인 'S AM'의
아이덴티티 포스터, 바젤디자인학교의 연간 패션 카탈로그와 2016년 팅글리
미술관에서 개최된 미하엘 랜디 전시 카탈로그 디자인이 있다.

잇다, 최성웅

노동공유형 독립출판 프로젝트 '잇다'의 번역가. 국문학을 전공했다. 파리 제3대학에 입학한 후 파리, 베를린, 뮌헨을 전전하며 불문학, 독문학, 비교문학을 공부했다. 2012년 귀국 후 출판 마케터와 편집자로 일했으며, 현재는 프랑스어와 독일어 통·번역가로 활동하고 있다.

잇다, 김보미

노동공유형 독립출판 프로젝트 '잇다'의 편집자.

타니아 프릴

브레멘과 취리히를 오가며 일하는 교수이자 디자이너. 브레멘예술대학과 취리히 예술대학에서 시각디자인을 전공하고 바젤디자인학교에서 석사과정을 이수했다. 현재 알베르토 비첼리, 세바스티앙 크레머스와 함께 취리히에 기반을 둔 '프릴 비첼리 크레머스'를 운영하며 브레멘예술대학에서 타이포그라피를 가르치고 있다.

파얌 샤리피

모스크바와 파리를 오가며 강연하는 작가 겸 예술가. 컬럼비아대학교와 영국 왕립예술대학을 졸업했고 『뉴욕 타임즈』, 『리버레이션』, 『아트 리뷰』, 『블랙 스퀘어』, 『퍼플』 등에 기고했다. 2006년에는 크리스조브 피다와 함께 '슬라브스와 타타르스'를 공동 설립했다.

프레시 프린트

타니아 프릴이 이끄는 브레멘예술대학 출판 동아리로, 학생들이 제작한 책, 잡지, 아티스트 북, 만화, 저널, 포스터, 달력, 엽서 등을 전시하고 판매한다. 다른 예술학교와의 교류와 협력을 적극적으로 지원한다.

현영석

2012년에 발간을 시작한 독립잡지 『록'셔리』 편집장. 한경대학교 디자인학부 커뮤니케이션 디자인을 전공했다.

People

Ana Brankovic

Designer and director working in the fields of culture, society, and publishing in Basel, Switzerland. She studied media science and economics at the University of Basel and completed a Masters' degree in visual communication and iconic research at the Basel School of Design. She co-founded Basel's online local platform, the wie war's mal mit. She is currently working on a Zine about hyperlocal journalism and publishing based on the example of Feldbergstrasse in Basel.

Barbara Wien

Artist book collector, publisher, and gallery owner in Germany. She majored in German language and history at the Albert Ludwig University of Freiburg and the Free University of Berlin. Since then, she has worked as an art critic and editor in Berlin and published interviews and articles about artists including Dieter Roth, Nam-joon Baek, Gunter Brus, Kubota Shigeko, and Hermann Nitsch. She established a publishing house called Wien Press in 1988 that has both a gallery and a bookstore dealing with artist books since the 60s. From 2013, she has directed and published a book series called "Way of Writing" containing contributions from artists like Haegue Yang, George Brecht, and Thomas Schmidt.

Bettina Brach

Curator at the Center for Artists' Publications located in Bremen Weserburg Museum. She helps with the management of archives, organizes exhibitions and guides researchers in their work.

Fresh Prints

A publication platform at the University of the Arts Bremen led by Tania Prill. The team exhibits and sells various types of student publications ranging from books, magazines, artists' books, zines, comics and journals to posters, calendars and postcards. Fresh Prints encourages exchange and cooperation with other art schools.

Hyun Young-seok

Editor of "Rock'xury", an independent magazine first published in 2012. He majored in communication design in the Design School of Hankyung University.

Iro

He runs a bookstore "Your Mind" and the Seoul art book fair "Unlimited Edition" since 2009. He founded a publishing house with the same title of "Your Mind" in 2012 and since then, publishes books based on the works of young artists. His publications include "Wit and Design" (co-authored, g:, 2013), "Cut by Back Cover" (i-bom, 2014), and "16 hour: Clear Ghost" (Ahn Graphics, 2014), and is currently writing a book to be published in 2017.

Itta, Choi Sung-woong

Translator of labor-sharing independent publishing project "Itta". Majored in Korean literature. After entering the University of Paris III, he studied French literature, German literature, and comparative literature in Paris, Berlin, and Munich. After returning to Korea in 2012, he worked as a publishing marketer and editor. He currently works as a French and German inter-preter/translator.

Itta, Kim Bomi

Editor of the labor-sharing independent publishing project "Itta".

Jeon Ga-gyung

She majored in literature at Ehwa Women's University, then went to the post-graduate school of Seoul National University and did visual design at the post-graduate school of Hongik University. After graduation she worked as the publication team leader in the design studio AGI Society. Starting with her Masters thesis at Hongik University "Pictures as Text and Society as Image: Men's Dealing of Pictures"(2006), she currently researches mediums of "picture – text – design". A photo book publishing house "Aprilsnow" that she runs with Jeong Jae-wan is an extension of this interest. Starting with "In-Between" published in 2013, she has since published 6 books and contributed writings about graphic design in numerous publications.

Jiri Oplatek

He teaches students of the Basel School of Design and runs a design studio. After co-founding Claudiabasel Grafik & Interaktion together with Roland John and Thomas Bircher in 2013, he has mainly worked on autonomous projects. The projects linked with cultural institutions include identity posters of Basel's architecture museum, S AM, annual fashion papers of the Basel School of Design, and a catalogue design of Michael Randy's exhibition held in Tinguely Museum in 2016.

Koh Sung-bae

Editor of the self-published independent magazine, "The Kooh", published since 2014. He runs a retro style book café "Holiday Avangoong".

Manuel Raeder

Designer living and running a studio in Berlin. After studying at the London College of Printing, he completed a post-graduate course in Jan van Eyck Academie. He established Studio Manuel Raeder based in Berlin and Mexico City in 2003 and founded a publishing house "Bom Dia Boa Tarde Boa Noite" in 2011. He focuses on collaborations with artists, designers, theorists, musicians, and curators. His work has a wide range of formats such as exhibitions, books, editing, publishing, handwriting design, and furniture design.

Payam Sharifi

Writer, artist, and lecturer based between Moscow and Paris. He graduated from Columbia University and the Royal College of Art and has written for the New York Times, Liberation, Art Review, Black Square, and Purple. In 2006 he co-founded Slavs and Tatars with Krzysztof Pyda.

Tania Prill

Professor and designer working in Bremen and Zurich. She majored in visual communication at the University of the Arts Bremen and Zurich University of the Arts and completed a Master's degree at the Basel School of Design. She currently runs "PrillVieceliCremers" based in Zurich with Alberto Vieceli and Sebastian Cremers and teaches typography at the University of the Arts Bremen.

CUBE

들을 수 없는 언어

들을 수 없는 언어가 뭐냐고요? 그게 무슨 뜻이죠? 이 상한 질문이군요. 음... 들을 수 없다면 적어볼 수 있지 않을까요? 머릿속에 떠다니는 언어는 들을 수 없지만 볼 수는 있잖아요.

'아는 만큼 보인다'라는 말이 있듯이 들리는 만큼 보이지 않을까요? 모르는 언어는 보이지 않겠죠. 상식 밖에 있는, 자신이 경험하지 못한 것들에 대해선 반응하기 힘들어요. 어떤 것을 듣고 보든 간에 제가 경험해보지 않은 것에 대해서는 말할 수 없지 않나요?

동물의 세계, 동물의 언어 아닐까요?

『두이노 비가』[1]에 의하면 들을 수 없는 언어는 바로 천사의 언어예요. 듣는 방식이 '귀 기울여 듣다(listen)'인지 '들리다(hear)'인지에 따라 답이 갈릴 순 있겠지만, 귀 기울여 듣되 '나'이면 들을 수 없는 것이 릴케[2]의 시에서 말하는 천사의 언어죠. 천사는 인간의 인식 범위 안에서는 가늠할 수 없는 존재거든요. 그게 아니라면... 데시벨이 낮은 소리나 외국 어가 될 수 있겠죠.

'들을 수 없는 것'과 '이해할 수 없는 것'은 완전히 달라요. 세상에 들을 수 없는 언어는 수만 가지예요. 몸짓, 표정, 눈빛, 열, 색깔, 중력은 들을 수 없어요. 명확히 '청각기관'을 통한 언어라면 들을 수도 있겠죠. 하지만 앞서 설명한 요소들은 들을 수 없지만 촉각, 시각, 후각과 같은 다른 감각기관을 통해 감지할 수 있어요. 감각을 기반에 둔 언어가 존재한다는 것은 부정할 수 없는 사실이에요. 따라서 질문이 '들을 수 없는 언어'에 대한 것이라면 감각기관과 관련된 많은 것들이 존재하겠지만 '이해할 수 없는 언어'라면 그건 완전히 다른 질문이에요.

결국 듣는다는 것은 열린 마음가짐과 개개인의 역량에 달려있어요. 다양한 언어가 존재하지만, 몸짓 언어와 같이 소리로 소통하지 않는 언어가 있듯이 '언어'를 정의 하는 것 자체는 개개인의 몫이에요.

저 자신을 '인간', '동양권에 있는', '한국인', '남성', '이성애자', '저소득층'이라 분류했을 때, 제가 들을 수 없는 언어는 이 분류에 속하지 않은 사람들의 언어예요. 저와 같은 부류의 사람이 하는 말은 제가 제일 쉽고 편안하게, 부담 없이 들을 수 있는 말이지만, 그렇기 때문에 제게는 아무런 쓸모가 없어요. 그래서 제게 제일 중요한 건 들을 수 없는 말을 노력해서 듣는 것이고, 그것이 독립출판의 맥락 중 하나이기도 해요.

저는 가장 소통이 안 되는 지점, 거기에서 생기는 장애와 갈등에 대해 듣고 싶어요. 그것을 통해 제가 가진 의심이나 불안이 깨지는 게 중요하죠. 결국 들리지 않는 언어를 어떻게 찾아들어야 하는 지가 관건인데... 그런 면에서 독립 출판 혹은 서점은 제게 자비로운 방식인 거죠. 예상하지 못한 것을 계속 받게 되니까요.

문자 자체는 객관적이라 할지라도 우리는 경험을 통해 감각화된 뜻을 받아들여요. 대부분의 사람이 편견 속에서 감각을 카테고리화하는데, 이를테면 홍어를 먹고 "캬, 죽이네." 하거나 "썩은내 뭐야!" 하듯이, 감각은 받아들이는 순간 관념 자체가 달라지는 거예요. 따라서 관념을 드러낸 상태로 접근하면 언어 속에 내포된 본연의 의미를 찾을 수 있을 거예요.

데카르트[3]는 말했죠, "나는 생각한다. 고로 존재한다." 저는 이 생각에 반대해요. 우리가 생각하기 때문에 더 우월하다는 뉘앙스의 말에 동의할 수 없어요. 근래에 들어 서양 사람들도 위, 심장과 같은 신체 기관도 뇌만큼 의식이 있는 존재라는 아유르베다적인 개념에 대해 이해하기 시작했어요. 동의학에도 비슷한 개념이 존재한다고 알고 있어요. 뇌는 우리가 이성적으로 이해할 수 있는 많은 언어를 가지고 있어요. 마찬가지로 다른 신체 기관도 우리에게 말을 하지만 우리는 그 기관이 보내는 신호, 그 언어를 이해하지 못해요. 어떤 이는 뇌가 다른 기관보다 우월하다고 이야기하지만 실제로는 그렇지 않아요.

언어와 관련된 신체 기관은 사실 성적으로 매우 민감한 부분들이에요. 코, 입술, 입, 이빨, 목, 목구멍, 귀 모두 관능적이고, 성적이며, 예민한 부위죠. 하지만 '언어'에 연관 지어 생각할 때 우린 항상 혀만 떠올려요. 지극히 과학적이고 임상적인 관점에서 말이에요. 저는 언어를 피부로 느끼는, 더 육감적이고 감각적인 신체 일부로 인식해야 한다고 생각해요.

∞　베를린에 한 헌책방이 있었는데, 와인을 마시면서 낭독회를 한다는 얘기를 듣고 가봤어요. 누구는 폴란드어로, 누구는 영어로 낭독하며 언어가 혼용되었지요. 단어의 의미를 이해하지 못하고 리듬만 들어도 좋았어요.

⇄　트리스 보나미셸[4]이라는 예술가와 협업한 이야기를 해드릴게요. 그는 본인의 경험을 이야기의 형태로 관객에게 전달하는 퍼포먼스 작가예요. 그는 관객 앞에서 빠른 속도로 구체시(Concrete Poetry)를 낭독해요. 따라서 그의 작업은 '입에서 나는 소리'와 '텍스트'의 콜라주와 같아요. 저희의 역할은 이러한 퍼포먼스를 책의 형태로 고스란히 기록하는 거였어요.

　그 결과물로 두 버전의 책을 제작했어요. 같은 ISBN 번호를 가진 이 책은 동일한 모습을 띠고 있지만 이를 구성하는 글의 순서가 달라요. 물론 삽입된 인쇄물도 다르고요. 인쇄물에는 트리스의 언어와 호흡의 리듬을 문자 간의 간격과 공백으로

재현한 다양한 실험이 담겨 있어요. 그가 각각의 퍼포먼스에 따라 원고를 변형하듯, 예술작업이란 고정되지 않은, 매번 변화하고 발전한다는 것을 암시하기 위해 선택한 방법이에요.

이러한 퍼포먼스 작업은 구두로 전달되는 일시적인 사건이에요. 책과 같은 물성, 즉 물리적인 오브제가 없죠. 따라서 퍼포먼스에 사용된 글과 문장을 어떻게 언어와 타이포그라피로 치환시킬지와 현장에서 느낄 수 있는 낭독 속도와 음조를 어떻게 담을 것인지가 이 책의 핵심이에요.

Words That You Can't Hear

"Words that I can't hear?" What does that mean? It's a strange question. Hmm... If I can't hear them, I will try to write them down first. We can't hear the words drifting in our heads but we can see them.

There is an idiom which says, "your knowledge determines your insight". So wouldn't you be able to see as much as you hear? You won't be able to see the words that you don't know. It's difficult to react to things that are beyond common knowledge and that you haven't experienced. Regardless of what you hear and see, you won't be able to talk about things that you haven't experienced, no?

 Maybe it refers to an animal kingdom of animals or their languages.

According to Duineser Elegien[1], words that you can't hear are the words of angels. Whether the answer will be different depends on whether the question is "to listen" or "to hear". Rilke[2]

describes the words of angels as the words you can listen to but can't hear if the subject is oneself. That's because an angel is something that can't be understood within the scope of human recognition. If this is not the case, perhaps your question refers to low-decibel sounds or foreign languages.

Something that you can't "hear" and something that you can't "understand" are two totally different things. There are a lot of languages that you can't hear. Languages that are related to body, facial expression, eyes, heat, color, or gravity are something that we can't hear. If you mean hearing as with your ears, then it's not a problem. But these are the languages that you don't necessarily "hear" with your ears but "feel" with your senses by touching, seeing, or smelling them. It's the fact that there are many languages based on senses. So if you are asking me about the language that you can't "hear", I think there are many that are related to other senses. But if you are asking me about the language you can't "understand", that's a completely different question.

Indeed, hearing depends on yourself and how open you are. Even if many types of languages exist, defining "language" is really up to you. As we know,

there are many other languages that are not necessarily communicated by sound.

When I categorize myself as "human", "living in East Asia", "Korean", "male", "heterosexual", and "low-income class", the words that I can't hear are the words of people who do not belong to these categories. Of course I can easily and conveniently pick up the words from people who belong to similar categories as myself. But for that reason, those words become useless. What's important for me is to make an effort to listen to the words that I can't hear. This attitude is crucial in the context of independent publishing as well.

I want to pay attention to problems and conflicts which arise from the point of miscommunications. This practice is important to dispel suspicion and anxiety that has built up inside of me. What matters is to search for the words that I can't hear. In this sense, independent publishing is a merciful route because it keeps pushing me to face things that are quite unexpected.

Even if the words are objective, when it comes to adopting, we take its sensuous meaning based on our experiences. Most people categorize

sensory experiences within their own prejudices. As if one says, "it's damn good" while the other says, "it stinks!" over the same fermented fish meal, when the experience comes to senses, it changes our idea about the subject. So if we free these limitations and are open to our senses, we will be able to catch the intrinsic meaning of the words.

René Descartes [3] said, "I think therefore I am". We are against this idea. We are against the idea that because we think, we are somehow superior. Nowadays, western people start to understand the Ayurvedic idea in which our body organs like stomach and heart are just as conscious as our brain. I believe there is a similar concept in Korean traditional medicine as well. Brain has many languages that we can rationally understand. And just like the brain, other organs also speak to us but we just don't understand what they are saying. Some people say the brain is superior to other organs, but it is not true.

If you think about it, all the organs related to languages are super erogenous. Your nose, lips, mouth, teeth, neck, throat, and ears are all erotic, sexual, and sensitive body parts. But when these organs are associated with languages, we only think

of the tongue in a very clinical and scientific way. Languages must be considered more closely with our flash in a physical sense.

There was an old bookstore in Berlin. Someone told me that they would be holding a poetry reading along with wine so I went. The recitation had a mixture of languages as some read their poems in Polish and some in English. Though I couldn't understand anything, I enjoyed it very much by simply listening to their rhythm.

I would like to tell you about this collaboration which I did together with the artist named Tris Vonna-Michell[4]. He's a performance artist who conveys a story about his personal experience. When he performs, he stands in front of the audience and reads fast concrete poetry. So most of his works are like oral and text based collages. My job was to transcribe his performance into book-form.

For the final output, we made two versions of the book. They looked exactly identical and had the same ISBN number but the stories were altered by changing the order of the texts. Of course the inserts were different too. The inserts contained various experiments of transcribing Tris' language and rhythm

of breathing into the spaces in between the texts as well as the spaces that are left out. As his manuscript changed according to each performance, we wanted to imply a message that artistic works are not fixed but rather ever-changing and evolving.

So the work itself is ephemeral and oral. It means, there is no physical object which can be translated into a book. So this is very much what this book is about: How to transcribe a piece of manuscript into typography and language and to revive the speed and the articulation of the reading from the site.

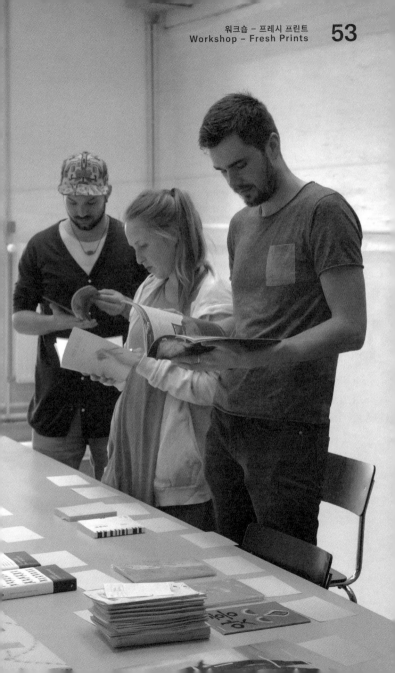

프레시 프린트

BB2 프로젝트의 첫 워크숍은 독일에 있는 브레멘예술대학에서
이루어졌다. 한때 항구의 물류창고였던 긴 벽돌식 건물은 이제
학생들을 위한 배움터로 제 역할을 찾은 듯했다. 우리는 워크숍과
함께 이후 '아이 네버 리드' 페어에 함께 참여할 프레시 프린트
그룹을 만나기 위해 서둘러 약속한 장소로 발걸음을 옮겼다. 학생
들의 작업으로 가득 찬 복도를 지나 한 교실 문을 열자 다소 생소
한 모습의 학생들이 우리를 기다리고 있었다. 하나둘 빈자리가
채워지고, 자신을 '소피'라고 소개한 여학생이 기다렸다는 듯 입을
열었다. "이곳에서는 대학에 속한 그룹을 통틀어 독일어로
'아르바이츠게마인샤프트(Arbeitsgemeinschaft)', 혹은 짧게
'아게(AG)'라고 불러요. 쉽게 말하면 작업 공동체예요. 프레시
프린트 또한 '아게'로서 담당 교수인 타니아 프릴과 함께 학생들이
직접 책을 디자인하고 엮는 작업을 해요." 그룹 소개가 끝나고
우리도 자연스럽게 BB2 프로젝트의 의미와 진행 과정, 그리고
앞으로 참여할 북페어에 대한 계획을 이야기했다. 프레시 프린트
그룹 학생들은 설명을 들으며 자신이 만든 책이 다른 학교의
책들과 어떻게 한자리에서 어울릴 수 있을지 고민하는 듯 보였다.

이날은 페어를 위한 구체적인 계획을 세우기보다는 서로의 책을
읽어보는 것에 집중하기로 했다. 프레시 프린트 학생들은 지금까지

만들었던 책을, 우리는 파티 학생들이 만든 책과 국내 출판물의
다양성을 보여주기 위해 가져온 몇 권의 책을 보여주었다. 각자의
을 늘어놓고 책에 대한 직관적인 느낌을 종이에 적은 후 이야기를
나누었다. 언어가 달라 직접 책을 소개하기보다 이러한 방법을
통해 서로의 책에 대해 더 자세히 알 수 있었다. 독일어로 된 책
을 읽을 수는 없었지만 이미지를 통해 책의 내용을 어느 정도 파악
할 수 있었다. 한국어를 읽을 수 없는 것은 프레시 프린트 학생들
도 마찬가지였고 그들 역시 책의 비슷한 방법으로 내용을 유추했
다. 이렇게 첫날은 책에 대한 각자의 생각을 공유하며 어색함을
허무는 시간으로 마무리했다.

다음 날은 타니아 교수도 함께 참여해 아트북페어 준비를 위한
첫 번째 회의를 시작했다. 단순히 책을 팔고 홍보하는 것이 아닌
학생들이 협업해 제작한 독립출판물을 어떻게 하면 관람객에게
효과적으로 보여주고 어렵지 않게 설명할 수 있을 것인가에 대해
토론했다. 서로 생각을 나눈 끝에 우리는 관람객이 쉽게 접근
할 수 있게 하나의 콘셉트를 강조한 부스를 만들기로 했다. 하지만
바로 콘셉트를 만들어내기가 쉽지 않았다. 우리는 커다란 전지
두 장을 벽에 붙이고, 그곳에 세 학교를 나타낼 수 있는 이미지를
그리거나 짧은 단어를 적으며 가볍게 시작해보기로 했다. 세 학교
의 협업에 집중하다 보니 세 가지의 어떤 것으로 구성된 이미지
들이 많이 나왔다. 벽에 붙은 전지를 흥미롭게 바라보던 타니아는
'Hi! Buy Bye'라는 장난스러운 문구를 발견하고는, 이렇게 세 개

의 낱말로 이루어진 다양한 문구를 만들어보자고 제안했다. 모두 게임을 하듯 재미난 문구를 적기 시작했고, 곧 추가된 두 장의 전지를 포함해 총 네 장의 전지가 빼곡해졌다. 그 이후엔 관객들의 시선을 끌고 호기심을 불러일으킬 한 문구들을 신중히 골라냈다. 마지막엔 총 여덟 개의 문구가 남았고, 손글씨 형태로 인쇄되었을 때 가장 보기 좋은 'Hey Shy Boy'를 대표 문구로 골랐다.

마지막 날에는 네 팀으로 나눠 전날 고른 단어들로 결과물을 만들어내는 데 집중했다. 관람객의 호응을 높이기 위해 만들기로 한 엽서의 앞면에는 여덟 개의 문구를 넣고, 뒷면에는 BB2 프로젝트에 대한 설명과 협업 과정에 대한 글을 넣어 리소프린팅 했다. 에코백 앞면에는 대표 문구인 'Hey Shy Boy'를 실크프린팅했다. 관객들이 계속해서 책을 집어보게 하기 위해 테이블보를 제작하기로 하고 책상 크기와 올라갈 책의 위치를 정확하게 계산해서 도면을 만들었다. 독자가 관심 있는 책을 들면 그 밑에 미리 고른 여덟 개의 문구 가운데 하나와 책의 가격이 드러나는 방식으로 제작했다. 부스를 지키는 학생들이 입을 셔츠에는 그들이 각자 고른 문구를 실크프린팅했다. 통일감을 주기 위해 모든 인쇄물은 파란색만 사용했다.

그렇게 공식적인 워크숍 일정이 끝났다. 우리는 3일 동안 같은 목표로 함께 작업한 프레시 프린트 그룹에 고마움을 전하기 위해 학교 카페를 빌려 한국 음식을 만들어주었다. 감자전과 만두,

먹고 싶은 재료를 골라 싸서 먹는 김밥과 같은 단출한 식사였지만
함께 먹으며 미처 나누지 못했던 말들을 주고받았다. 와인과
맥주를 마시며 대화를 하는 동안 시간은 금방 흘렀고, 우리는
마지막 버스를 타기 위해 아쉬운 작별인사를 나눴다.

브레멘예술대학교에서의 3일은 우리가 스스로 콘셉트를 찾고
실제 결과물까지 만들어내는 데 부족함이 없는 시간이었다. 프레시
프린트 그룹 학생들과 처음 만나 협업을 한다는 점은 결코 쉽지
않았지만 간단한 영어 단어로 게임하듯 작업한 덕에 이질감
없이 서로의 생각을 공유할 수 있었다. 사용하는 언어가 달라도
소통하는 방법을 함께 찾아 찾아내는 과정이 있었기에 좀 더 편한
분위기에서 의견을 모을 수 있었다. 팀의 콘셉트를 만들어낸다는,
자칫 너무 진지해질 수도 있었던 과정에서 자신의 아이디어를
고민하지 않고 바로 실행하는 프레시 프린트 학생들은 우리에게
큰 활력소였다.

Fresh Prints

The first workshop of the BB2 project took
place at the University of Arts Bremen in
Germany. A long brick building, once used
as a warehouse for the harbor, seemed to
find its role as an educational place for
students. To meet Fresh Prints, a group
of workshop collaborators, who would also
participate in the I Never Read book fair
together with us, we quickened our pace.
Passing by the hallway full of students'
works, we arrived in front of the class-
room and when the door opened, students
with unfamiliar faces were waiting for us.
The empty seats were filled one by one,
and a girl who introduced herself as Sophie
opened up the conversation: "In here, we
call the groups that belong to the univer-
sity 'Arbeitsgemeinschaft' or in short:
'AG'. Simply put, it's a working collective.
Fresh Prints is also one of these AGs.
We design books and make publications to-
gether with Tania Prill, the directing
professor of the group". After Sophie's
introduction, we as well spontaneously ex-
plained the meaning of the BB project, its

process, and the future plans about par-
ticipating in the book fair. Fresh Prints
students listened carefully and seemed to
be thinking about how the books from dif-
ferent schools could be presented together
as a whole.

On the first day, we decided to read each
others' books rather than stepping into
the concrete concept right away. Fresh
Prints brought books they designed, and we
showed books from PaTI students along with
other independent publications which we
had also brought from Korea as examples to
show its diversity. We spread out each
others' books, took notes about our intui-
tive feelings, then shared the impressions.
Since we spoke two different languages, we
used note-taking as a way to have deeper
knowledge about the books, instead of ex-
plaining verbally. Though German texts
were unfamiliar, we could get rough ideas
about the books by getting hints from the
images. The language problem was no differ-
ent for the Fresh Prints students, but they
as well made close guesses. While listen-
ing to others' thoughts, everyone got more
comfortable to each to other and by doing
so, the first day's workshop ended.

The next day, professor Tania joined the
meeting and we discussed preparing the book
fair. The discussion was not about selling
or promoting books, but rather about how
we were going to present books from three
schools as a case of collaboration. After
sharing each others' opinions, we finally
decided to present our table at the book
fair with one unified concept. Yet the
concept was still unknown. To find a way,
we put two large sheets of paper on the
wall and started to draw and write images
and words which could signify the three
schools as a whole. While being concen-
trated on the aspect of "the three schools'
collaboration", many images turned out as
combinations of "three things". In the
meantime Tania, looking at the paper with
interest, found the phrase "Hi! Buy Bye",
and suggested we create more phrases con-
sisting of three different words each.
Everybody began to write as if they were
playing a game and soon after, 4 sheets
of paper—including two extra sheets which
were added later—were filled with various
phrases. Afterwards, we picked those which
would most likely intrigue the viewer's
curiosity. In the end, a total of 8 phrases

remained and "Hey Shy Boy", a piece of
handwriting that looked best in printed
format, was selected as the main slogan.

Dividing the works into four groups, the
last day's process focused on creating
final output from the chosen phrases.
Postcards seemed to be the most accessible
format; therefore, on the front, we ran-
domly placed one of the eight slogans and
on the back, the description of the BB2
project as well as the process of the col-
laboration. Output was produced by riso-
graph. The Ecobag group was in charge of
silkscreening the main slogan "Hey Shy Boy"
on the front side of the bag. In order to
incite audiences to continue picking up
the books, we also decided to design a
special tablecloth. After researching the
exact size of the fair table, we created
the tablecloth in a way that one of the
phrases is revealed when the customer lifts
up a book. Lastly, we prepared shirts—
uniforms—which we would wear at the fair.
Once the participants had each chosen a
slogan they liked best, we silkscreened
these as well.

Our official workshop schedule was over and we invited the Fresh Prints students to dinner. To express our gratitude to the Fresh Prints students who had spent three full days working with us under the same goal, we rented the cafeteria of the school and served Korean foods. Though they were not the most luxurious dishes, while having potato pancakes, dumplings, and the Korean-style sushi which people could make their own pieces, we spent the rest of the night catching up on belated conversations. With wine and beer, time flew by and to catch the last bus, we had to make our farewells unwillingly.

Three days at the University of Arts Bremen were enough time to build a concept together and turn it into final output. Having a collaboration together with people we had met for the first time wasn't so easy, but because we worked together as if we were playing a game—based on simple English words—we were able to share our ideas more openly without having to feel distanced. Despite the fact that our languages were different, through the process of finding another way to communicate, it was possible to bring our

opinions together. Creating a single concept representing three distinct schools could have been a tough task—yet, being with the Fresh Prints students who turned their ideas into action without hesitation, the whole process remained a dynamic experience.

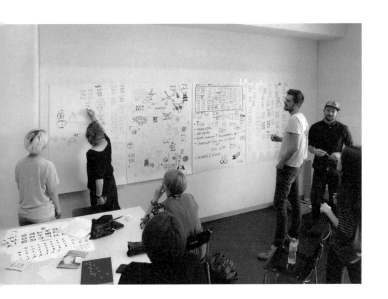

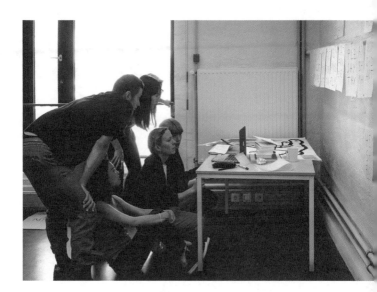

This publication project "BB 2: Bremen to Basel" during the trip-based publication project "BB 2: Bremen to Basel". A group of students at the Typography Institute visited Bremen, Berlin, and Basel to open up liberal conversations on the independent publishing scenes from different cultural backgrounds.

This collection of books is part of the trip-based publication project "BB 2: Bremen to Basel". During the program, PaTI students had a collaborative workshop with Fresh Prints student publishing group from the University of the Arts Bremen to participate together at "I Never Read", which was sponsored by Basel School of Design and University of the Arts Bremen. The goal was to tie different schools – PaTI, Basel School of Design and University of the Arts Bremen – by creating an identity which represents the uniqueness of each school at a combination of these trip experience on book fairs. The documentations of the trip which was composed of interviews, direct experience on ideas of independent book publishing will later be collected and published by PaTI as the book "BB 2: Bremen to Basel" in 2017.

This collection of books is part of the publication project "BB 2: Bremen" during the Typography Institute visited Bremen. A group of students at the Basel to open up liberal conversation pendent publishing scenes from different backgrounds.
During the program, PaTI students rative workshop with Fresh Prints student publishing group from the University to participate together at "I Never Read" which was sponsored by Basel School of Design and University of the Arts Bremen – by creating an identity which represent a combination of these works.
The documentation of the trip which was composed of interviews, direct experience on ideas of independent book publishing will later be collected and published by PaTI as the book "BB 2: Bremen to Basel" in 2017.

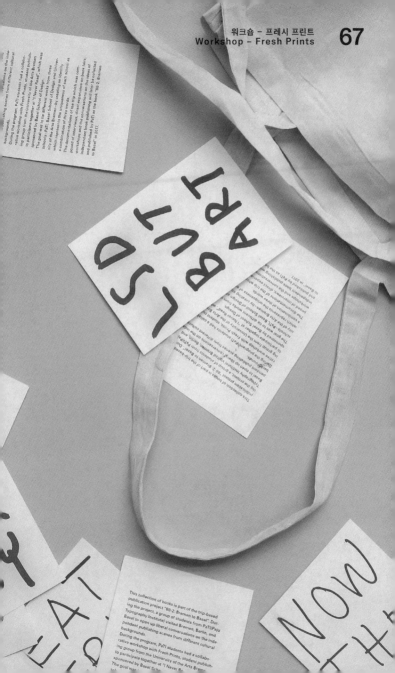

읽는 행위

슬라브스와 타타르스[5]를 설립한 후, 초기 3년간은 '읽기'라는 주제로 작업을 하며 많은 전시를 기획하고 설치했죠. 당시 저희가 직면했던 어려움은 관객은 읽어도 된다, 혹은 읽지 않아도 된다는 선택권을 주면 무조건 읽지 않는다는 거예요.

지금 한국에서 독서운동을 하는 분들은 책을 '읽는 대상'이라고 생각해요. 그런데 바젤 북 페어의 슬로건을 보면 "난 절대 읽지 않아(I Never Read)"죠. 저는 이게 중요한 키워드라고 생각해요.

이미지 중심의 책을 접했을 때 우리는 읽지 않아요. 보는 거죠.

이란에 여행 갔을 때 환전이 필요해서 어떤 상점에 들른 적이 있어요. 상점 안에는 각 지역의 화폐를 수집해 모아둔 상자가 있었는데, 그 안에 화폐를 구경하다가 거기서 꼬박 하루를 보냈죠. 당시 상점 주인은 제가 어떤 기준으로 화폐를 고르는지 의아해했어요. 그럴 법도 한 것이 제겐 화폐의 금전적 가치보다 심미적 가치가 더 중요했기 때문이에요.

독어권에서 디터 로스[6]는 중요한 인물로 존경받고 있어요. 좋은 의미로 미친 사람이었기 때문이죠. 그는 거의 모든 재료를 작업으로 승화시켰어요. 폐지도 예외는 아니에요. 그는 다양한 종류의 폐지를 모아 총 40권의 전집으로 출판했어요. 폐지를 사용했기 때문에 똑같은 책이 없어요. 서너장만 봐도 어떤 형태의 책인지 금방 파악할 수 있고 뒤집어 읽어도 상관없어요. 이러한 작업은 우리가 흔히 생각하는 전통적인 방식의 '읽을 수 있는 책'이 아니죠.

아마존닷컴[7]에서 『화폐』[8]를 구매한 남자가 화폐의 출처가 적혀있지 않다는 사실을 알고는 책을 쓰레기통에 버렸다는 글을 읽었어요. 사실 저희는 모든 화폐의 출처와 그에 대한 설명글을 가지고 있었어요. 하지만 출처가 공개되면 그 나라의 정체성과 정치적 성향을 배제하고 책을 이해하기 어렵다고 생각했기 때문에 글을 넣지 않기로 결정했죠. 유색 인쇄를 하지 않은 것도 같은 이유예요. 방해되는 요소를 줄여서 이미지 자체의 집중도를 높이고 싶었어요. 물론 색상이 꼭 필요한 몇몇 화폐에 한해 유색 인쇄를 했지만, 앞서 말했듯이 본래 계획은 모두 흑백으로 인쇄하는 거였어요. 저희는 독자가 국가적, 정치적 맥락을 떠나 아이코노그래픽(Iconographic)적 관점에서 이 책을 읽길 바라요.

매년 수만 장의 화폐가 생산되고 순환돼요. 우리는 매일 돈을 쓰지만 아무도 그 안에 담긴 이미지를 눈여겨보지 않아요.

저는 이러한 이미지의 본질을 찾고 싶어요. 화폐는 단지 종이일 뿐이에요. 화폐의 가치를 만드는 건 결국 그 위에 새겨진 이미지죠.

저희가 수집하는 아티스트북 중에는 독일어 외 다른 언어로 된 책도 많아요. 하지만 내용을 알기 위해 번역기를 돌리는 경우는 드물어요. 이건 책을 어떻게 보여주는지에 대한 문제이기도 한데, 전시할 때는 선정한 책의 기능이 무엇인지를 이해하는 정도예요. 책에서 드러나는 시각 이미지를 통해 전체적인 인상을 파악할 뿐이죠.

제가 슬라브스와 타타르스를 시작하게 된 계기는 서구의 합리주의적 사고가 지식과 문자의 전부는 아니라고 생각했기 때문이에요. 이러한 제한에서 벗어나면 책을 읽을 때 더욱 가슴 깊이, 온몸으로 느끼는, 한층 더 감각적인 관계를 맺을 수 있다고 믿어요.

저희가 진행하는 낭독회에서는 각자 준비한 시를 낭독해요. 같은 시라도 누구는 행과 열을 지키며 낭독하고 또 누구는 자기 호흡대로 특정 단어에 힘을 주는 것을 볼 때 개개인의 시를 보는 세계관이 드러나면서 '시를 읽으면 이렇게 달라지는구나' 알게 되었어요.

결국은 지식의 소재를 합리적이고 이성적인 방법 외에 어떤 방법으로 접근할 수 있는지가 핵심이에요. 분석적으로 접근하는 동시에 형이상학적으로, 감각적으로, 혹은 다른 방식으로 이해하려는 노력이 필요해요.

Action of Reading

The first three years after founding Slavs and Tartars[5], we did a lot of exhibitions and installations based on reading. The problem that we faced during this period was, if you give people a choice "to read" or "not to read", they always choose not to read.

In Korea, people who encourage reading regard books as "something to be read", but if you look at the slogan of Basel book fair, it says, "I Never Read". I think this is an important keyword.

When we take a look at an image-oriented book, we don't read it. We see it.

When I was traveling in Iran, I wanted to change money so I went into a shop where they had a box full of banknotes from the different regions. I was fascinated by the images on the banknotes and spent the whole day there. The shop owner didn't understand why I was choosing this or that banknote because I was only looking through the aesthetic criteria and not the monetary values of the banknotes.

◢ Dieter Roth[6] was an important figure in the German-speaking regions because he was crazy in the best sense. He made art out of almost everything. Waste paper was not an exception. He collected flat wastes in big files and later published them as a series of 40 books. There are no identical books because he used waste papers. You only have to read up to three or four pages because that's enough to identify the book. Also, it doesn't matter if you look at the book upside down. In this case, it's not a "readable book" in a traditional sense.

◯ I read a comment of the person who bought "Money"[7] from the Amazon[8]. He said he threw the book into the garbage because we didn't specify the origins of each banknote. In fact, we had the name of each country and the texts but we decided to take them out. We thought people would focus on political contexts if each banknote had its origin. That was also why we did not print them in color. The idea was to take colors away so people would concentration on the images. We ended up printing some papers in color which were necessary, but the original plan was to have all of them in black and white. We want people to read the book from the iconographic perspective without any national or political connotations.

Every year, millions of banknotes are produced and spread around the world. We use money everyday but nobody pays much attention to the image itself. I wanted to find the essence of these images. Money is paper, only paper. What gives value are the images that are imprinted on them.

We not only collect German books but ones that are written in other languages. However, it's rare for us to put them in a digital translator to understand the contents. Perhaps this is also related to the general issue of how we present books. When we hold an exhibition, we try to understand the function of the book by having an overall impression through its visual images.

We started Slavs and Tartars because the western idea of rationalism – which has its major emphasis on intellectuality – is not everything that underlies knowledge and text. I believe once we overcome this limitation, we can have a relationship with knowledge and text through our stomach and heart to be able to understand them physically and sensually.

When we organize a poetry reading, each person reads one that they prepared for the day. Some are more strict about rows and columns and some emphasize certain words based on how they breathe. By observing each person, I've realized that reciting poetry is completely different from simply reading it. By doing so, you can visualized one's own universe.

The key is to understand material knowledge in a non-rational way. Not only analytical but also metaphysical, sensual or the other way around to approach the fundamentals.

BORIS MIKHAILOV

Dietmar Dath
Christian Demand
Thomas Demand
Joachim Valentin
Klause

Archiv Peter Piller
Materialien (C)
\40 Bochum Dükerweg

Dear Gerhard _the box of the_
I sent to you tonights
of the „Salt Lake" in the
order. I would like to
have it. The number are
on the back side of Foto. Yours Boris

SALT LAKE

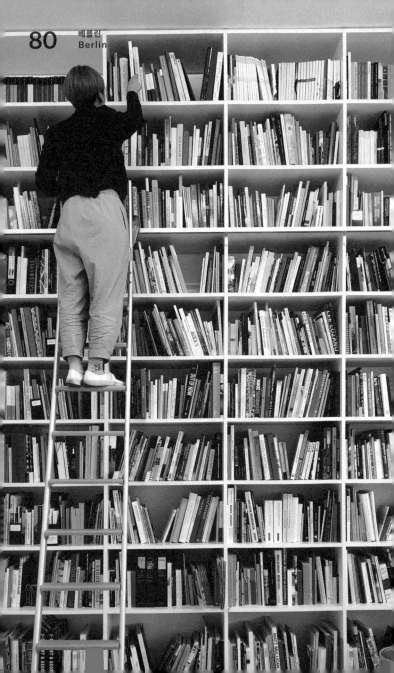

책

책은 아름다운 하나의 오브제여야 해요. 저는 책을 소유하기 위한 것으로 생각해요. 자극적이고 소유하고 싶은 것이 책이 지녀야 할 물성이에요.

저도 한편으로 책은 오브제라고 생각해요. 이건 작년에 디자인한 『GGG』[9]라는 책이에요. 오랜 역사에 대한 내용을 담고 있어요. 사람들이 매우 좋아했어요. 이렇게 오래된 소재를 다룰 때 저의 궁극적 목적은 어떠한 방법으로든 새롭게 재창조하는 거예요. 마치 하나의 오브제처럼.

'탈리스만'[10]이라고 들어봤나요? 지역마다 특별하고 신비한, 신성시 여겨지는 물건이 있듯이 책도 마찬가지예요. 같은 책이라도 스무살 때 읽는 것과 마흔이 되었을 때, 예순이 되었을 때, 사랑에 빠졌을 때나 이별을 하고 읽었을 때, 매 순간 다른 의미로 다가오지요. 책은 고정된 사물이 아니에요. 변화하는 것이지요.

'무한한 책'이라는 제목을 보면 무엇이 연상되나요? 뫼비우스의 띠? 검은 종이?

이건 팀 울리히[11]가 만든 『무한한 책』이에요. 두 개의 거울이 마주보면서 이미지가 무한히 반복되죠. 책을 테이블에 두었을 때 앉아 있는 위치에 따라 그 속에 비친 이미지도 각자 다르게 보일 거예요. 이게 이 책의 핵심이에요. 책이라는 매체에 보편적으로 사용되지 않는 재료를 사용해 놀라움을 주는 것이 결국 이 책의 콘셉트가 된 거죠.

이 영상을 한번 볼래요? 이건 노라 슐츠[12] 그리고 미하엘 보이틀러[13]와 함께 순수 예술 전공 학생들을 대상으로 한 워크숍이에요. 미술을 공부하는 학생들이 자신의 작업을 어떻게 기록하고 인쇄 가능한 형태로 변형할 수 있는지에 대해 질문하는 워크숍이었죠. 이 과정을 통해 모든 학생이 각자 자신의 포스터를 디자인했어요. 포스터가 만들어진 이후에는 보이틀러가 제작한 압축기에 모든 포스터를 넣고 짓눌러 하나의 묶음으로 만들었어요. 이렇게 탄생한 소시지 모양의 오브제가 최종 출판물이 되었죠.

책을 소유의 관점으로 보는 것은 긍정적이에요. 이것 또한 1980년대에 이미 나타난 것이기도 하고요. 책은 일단 디자인적으로 완성도가 높고 물성적으로 견고해야 한다고 생각하는데, 지금 한국에서 말하는 독립출판물은 그것과 별개로 참신한 내용을 말하고 있는 것 같아요. 용어도 한번 더 고민해

보면 좋을 것 같아요. 저는 독립출판이라는 말보다 '소규모 출판'이라는 말을 더 선호해요. '독립'이라는 단어가 들어가면 너무 거창해지기 때문에 규모로 판단해 '소규모 출판'이라 이야기하는 거예요.

　　'독립출판'이라는 말에는 귀속적인 성격이 강하기 때문에 언론에서는 독립출판물을 기이하고 신기한 쪽으로 바라보고 있어요. 그런데 중앙매체에서 관심을 두는 순간 왜곡되는 게 굉장히 많아요. 실제로 일어나고 있는 현상과 괴리되고 거리감이 느껴질 수밖에 없어요. 독립출판물의 정의는 계속 질문해야 하는 것 같아요. 어떤 방식으로 형식을 실험하고 어떤 새로운 관점에서 글과 사진을 조율해 나갈 것인지에 관해서요.

　　저희가 읻다 프로젝트에서 유일하게 내세운 건 '출판사를 다니는 사람들이 자기의 노동을 공유, 갹출하여 만든다'는 점이었어요. 이게 문화부 기자들이 관심을 가질만한 소재가 아닐까 생각했지요. 그러다 보니 '노동 공유형 독립출판 프로젝트'라는 거창한 말을 만든 것이고요. 책을 '오브제'라고 부르는 것도 고치면 좋겠어요. '오브제'는 불어를 바꿔 쓴 건데 왜 이 하나의 단어조차 우리말로 치환하지 못하는 걸까요? 책은 책으로 보면 되죠.

　　이건 윌리엄 코플리[14]가 1968년에 출간한 작은 원더박스예요. 그는 6가지 이슈에 대해 『SMS』라는 제목의

책/포트폴리오를 출간했어요. 『SMS』는 오늘날 우리가 알고 있는 단어와는 달라요. 'Shit Must Stop (쓰레기는 가라)'의 줄임말이죠. 정말 멋진 작업이에요. 평범하게 제본된 책은 물론 아니죠. 이 안에는 작은 오브제들과 함께 이들이 어떻게 배치되었는지에 대한 설명이 들어있어요. 사전에서 따온 문장을 엮은 작업이나 '사물(Thing)의 정의는 과연 무엇인가?'를 질문하는 사진 등, 모두 만 레이[15], 마르셀 뒤샹[16], 로버트 라우센버그[17]와 같은 세계적으로 유명한 예술가들의 작업이에요. 모두 아시겠지만, 60년대 예술가들은 공간의 제약에서 벗어나 새로운 환경, 형태, 매체를 찾기 위해 노력했어요. 이 시기에 주목받은 형태 중 하나가 정기간행물이었죠. 물론 인쇄 매체를 고수하는 예술가도 있었지만, 다른 한편에서는 인쇄 매체의 한계를 실험하는 작업이 이루어졌어요. 『SMS』는 후자의 경우로, 이러한 실험의 한 경지를 보여주고 있죠.

가장 빨리 이해해야 하는 측면은 책이 책이지만은 않다는 것이에요. 책은 이제 감상 가능한 미술품이자 인증가능한 기념품이라는 것을 아는 사람들이 자생력을 갖추고 최고의 결과물을 냈던 것 같아요. 빨리 품절되지만 책은 입체물이기에 소장하고 인증할 수 있고 그것을 아는 사람들끼리 끈끈하게 뭉치기 때문에 이렇게 굴러가는 거예요.

A Book

A book must be a beautiful object. I see a book as something to be owned. Stimulating and possessive – these are the properties that books should have.

I also somehow think of a book as an object. This is a book called "GGG"[9] which I designed last year. It has a lot of text about old historical things and people really liked it. When it came to designing a historical context, the goal was to somehow make it fresh again, like an object.

Do you know what Talisman[10] is? Many societies have a special and sacred objects which have magical importance. Books are almost like this. Depending on whether you read a book in your 20's, 40's, 60's, when you fall in love or are heartbroken, each time it gives a different pleasure and meaning. Books are not static objects. They always change.

 If you see a title called, "The Infinite Book" what do you imagine?

A Möbius strip? A black paper? This is "The Infinite Book" made by Timm Ulrichs[11]. It has two mirrors facing each other which create ever-repeating reflections. If you place the book on the table, you would see different mirror images depending on your seat. This is the principle of "the Infinite Book" which surprises by using materials that are not typical for books.

Would you take a look at this film? What you see is a collaboration together with Nora Schultz[12] and Michael Beutler[13]. We held a workshop with the students from a Fine Arts course. It was basically a workshop asking art students to document and reproduce their own works into a printed format.Through this process, each student designed a poster. Then we took the machine made by Michael Beutler, squashed all the posters together and collected them into one bundle. This sausage-shaped object was the final output.

It's a positive phenomenon to view books in terms of ownership. These changes have already existed since the 1980s. I believe books must have highly polished designs together with substantial materials, yet if you speak of "Independent Publications" in Korea, it seems to indicate the originality of the contents. I would also like to recommend the term, "Independent Publishing" be reconsidered. I prefer using "Small Press" because having the word "Independent" makes it seem too important. So I often say "Small Press" by simply referring to the scale of production.

Because the term, "Independent Publishing" has an ascriptive connotation, media views independent publishing is an interesting and bizarre phenomenon. But once the central media pays attention, it causes so many distorted facts that are completely alienated and distant from the reality. I believe we have to continue questioning the definitions of independent publications in terms of finding a new way to experiment as well as to adjust images and text from a different perspective.

The only aspect that we highlighted in Itta Project was "it is composed of people from publishing houses who donate their time and talents

to run the project". We thought this type of branding would draw attention from journalists in the field of Art and Culture. That's why we chose to use such big words such as "Labor-sharing Independent Book Project". In respect to choosing the words, I would also like to rethink how we refer to a book as an "objet" in Korea. It is a French word. Why can't we change this single word into Korean? Why don't we call a book simply a book?

　　This is a small wonder box published by William Copley[14] in 1968. He published six different issues of this book/portfolio under the title of "SMS". However, the meaning of "SMS" is not the one you would expect today. It stands for "Shit Must Stop". It's a fantastic work because it is not a book with a typical binding but a collection of small objects. It also has a plan description of how things were arranged. The book contains various works – a piece made up with the phrases found in a dictionary and a set of photos questioning, "what is the definition of a thing" – from world famous artists such as Man Ray[15], Marcel Duchamp[16], Robert Rauschenberg[17] and more. As you know, many artists in the 60's tried to look for new sites,

Action of Reading

The first three years after founding Slavs and Tartars [5], we did a lot of exhibitions and installations based on reading. The problem that we faced during this period was, if you give people a choice "to read" or "not to read", they always choose not to read.

In Korea, people who encourage reading regard books as "something to be read", but if you look at the slogan of Basel book fair, it says, "I Never Read". I think this is an important keyword.

When we take a look at an image-oriented book, we don't read it. We see it.

When I was traveling in Iran, I wanted to change money so I went into a shop where they had a box full of banknotes from the different regions. I was fascinated by the images on the banknotes and spent the whole day there. The shop owner didn't understand why I was choosing this or that banknote because I was only looking through the aesthetic criteria and not the monetary values of the banknotes.

Dieter Roth[6] was an important figure in the German-speaking regions because he was crazy in the best sense. He made art out of almost everything. Waste paper was not an exception. He collected flat wastes in big files and later published them as a series of 40 books. There are no identical books because he used waste papers. You only have to read up to three or four pages because that's enough to identify the book. Also, it doesn't matter if you look at the book upside down. In this case, it's not a "readable book" in a traditional sense.

I read a comment of the person who bought "Money"[7] from the Amazon[8]. He said he threw the book into the garbage because we didn't specify the origins of each banknote. In fact, we had the name of each country and the texts but we decided to take them out. We thought people would focus on political contexts if each banknote had its origin. That was also why we did not print them in color. The idea was to take colors away so people would concentration on the images. We ended up printing some papers in color which were necessary, but the original plan was to have all of them in black and white. We want people to read the book from the iconographic perspective without any national or political connotations.

Every year, millions of banknotes are produced and spread around the world. We use money everyday but nobody pays much attention to the image itself. I wanted to find the essence of these images. Money is paper, only paper. What gives value are the images that are imprinted on them.

We not only collect German books but ones that are written in other languages. However, it's rare for us to put them in a digital translator to understand the contents. Perhaps this is also related to the general issue of how we present books. When we hold an exhibition, we try to understand the function of the book by having an overall impression through its visual images.

We started Slavs and Tartars because the western idea of rationalism – which has its major emphasis on intellectuality – is not everything that underlies knowledge and text. I believe once we overcome this limitation, we can have a relationship with knowledge and text through our stomach and heart to be able to understand them physically and sensually.

When we organize a poetry reading, each person reads one that they prepared for the day. Some are more strict about rows and columns and some emphasize certain words based on how they breathe. By observing each person, I've realized that reciting poetry is completely different from simply reading it. By doing so, you can visualized one's own universe.

The key is to understand material knowledge in a non-rational way. Not only analytical but also metaphysical, sensual or the other way around to approach the fundamentals.

BORIS MIKHAILOV

Dietmar Dath
Christian Demand
Thomas Demand
Joachim Valentin
Klause

Archiv Peter Piller
Materialien (C)
\40 Bochum Dükerweg

책

책은 아름다운 하나의 오브제여야 해요. 저는 책을 소유하기 위한 것으로 생각해요. 자극적이고 소유하고 싶은 것이 책이 지녀야 할 물성이에요.

저도 한편으로 책은 오브제라고 생각해요. 이건 작년에 디자인한 『GGG』[9] 라는 책이에요. 오랜 역사에 대한 내용을 담고 있어. 사람들이 매우 좋아했어요. 이렇게 오래된 소재를 다룰 때 저의 궁극적 목적은 어떠한 방법으로든 새롭게 재창조하는 거예요. 마치 하나의 오브제처럼.

'탈리스만'[10] 이라고 들어봤나요? 지역마다 특별하고 신비한, 신성시 여겨지는 물건이 있듯이 책도 마찬가지예요. 같은 책이라도 스무살 때 읽는 것과 마흔이 되었을 때, 예순이 되었을 때, 사랑에 빠졌을 때나 이별을 하고 읽었을 때, 매 순간 다른 의미로 다가오지요. 책은 고정된 사물이 아니에요. 변화하는 것이지요.

'무한한 책' 이라는 제목을 보면 무엇이 연상되나요? 뫼비우스의 띠? 검은 종이?

이건 팀 울리히[11]가 만든 『무한한 책』이에요. 두 개의 거울이 마주보면서 이미지가 무한히 반복되죠. 책을 테이블에 두었을 때 앉아 있는 위치에 따라 그 속에 비친 이미지도 각자 다르게 보일 거예요. 이게 이 책의 핵심이에요. 책이라는 매체에 보편적으로 사용되지 않는 재료를 사용해 놀라움을 주는 것이 결국 이 책의 콘셉트가 된 거죠.

이 영상을 한번 볼래요? 이건 노라 슐츠[12] 그리고 미하엘 보이틀러[13]와 함께 순수 예술 전공 학생들을 대상으로 한 워크숍이에요. 미술을 공부하는 학생들이 자신의 작업을 어떻게 기록하고 인쇄 가능한 형태로 변형할 수 있는지에 대해 질문하는 워크숍이었죠. 이 과정을 통해 모든 학생이 각자 자신의 포스터를 디자인했어요. 포스터가 만들어진 이후에는 보이틀러가 제작한 압축기에 모든 포스터를 넣고 짓눌러 하나의 묶음으로 만들었어요. 이렇게 탄생한 소시지 모양의 오브제가 최종 출판물이 되었죠.

책을 소유의 관점으로 보는 것은 긍정적이에요. 이것 또한 1980년대에 이미 나타난 것이기도 하고요. 책은 일단 디자인적으로 완성도가 높고 물성적으로 견고해야 한다고 생각하는데, 지금 한국에서 말하는 독립출판물은 그것과 별개로 참신한 내용을 말하고 있는 것 같아요. 용어도 한번 더 고민해

보면 좋을 것 같아요. 저는 독립출판이라는 말보다 '소규모 출판'이라는 말을 더 선호해요. '독립'이라는 단어가 들어가면 너무 거창해지기 때문에 규모로 판단해 '소규모 출판'이라 이야기하는 거예요.

'독립출판'이라는 말에는 귀속적인 성격이 강하기 때문에 언론에서는 독립출판물을 기이하고 신기한 쪽으로 바라보고 있어요. 그런데 중앙매체에서 관심을 두는 순간 왜곡되는 게 굉장히 많아요. 실제로 일어나고 있는 현상과 괴리되고 거리감이 느껴질 수밖에 없어요. 독립출판물의 정의는 계속 질문해야 하는 것 같아요. 어떤 방식으로 형식을 실험하고 어떤 새로운 관점에서 글과 사진을 조율해 나갈 것인지에 관해서요.

 저희가 잍다 프로젝트에서 유일하게 내세운 건 '출판사를 다니는 사람들이 자기의 노동을 공유, 각출하여 만든다'는 점이었어요. 이게 문화부 기자들이 관심을 가질만한 소재가 아닐까 생각했지요. 그러다 보니 '노동 공유형 독립출판 프로젝트'라는 거창한 말을 만든 것이고요. 책을 '오브제'라고 부르는 것도 고치면 좋겠어요. '오브제'는 불어를 바꿔 쓴 건데 왜 이 하나의 단어조차 우리말로 치환하지 못하는 걸까요? 책은 책으로 보면 되죠.

이건 윌리엄 코플리[14]가 1968년에 출간한 작은 원더박스예요. 그는 6가지 이슈에 대해 『SMS』라는 제목의

책/포트폴리오를 출간했어요. 『SMS』는 오늘날 우리가 알고 있는 단어와는 달라요. 'Shit Must Stop(쓰레기는 가라)'의 줄임말이죠. 정말 멋진 작업이에요. 평범하게 제본된 책은 물론 아니죠. 이 안에는 작은 오브제들과 함께 이들이 어떻게 배치되었는지에 대한 설명이 들어있어요. 사전에서 따온 문장을 엮은 작업이나 '사물(Thing)의 정의는 과연 무엇인가?'를 질문하는 사진 등, 모두 만 레이[15], 마르셀 뒤샹[16], 로버트 라우센버그[17]와 같은 세계적으로 유명한 예술가들의 작업이에요. 모두 아시겠지만, 60년대 예술가들은 공간의 제약에서 벗어나 새로운 환경, 형태, 매체를 찾기 위해 노력했어요. 이 시기에 주목받은 형태 중 하나가 정기간행물이었죠. 물론 인쇄 매체를 고수하는 예술가도 있었지만, 다른 한편에서는 인쇄 매체의 한계를 실험하는 작업이 이루어졌어요. 『SMS』는 후자의 경우로, 이러한 실험의 한 경지를 보여주고 있죠.

가장 빨리 이해해야 하는 측면은 책이 책이지만은 않다는 것이에요. 책은 이제 감상 가능한 미술품이자 인증가능한 기념품이라는 것을 아는 사람들이 자생력을 갖추고 최고의 결과물을 냈던 것 같아요. 빨리 품절되지만 책은 입체물이기에 소장하고 인증할 수 있고 그것을 아는 사람들끼리 끈끈하게 뭉치기 때문에 이렇게 굴러가는 거예요.

A Book

A book must be a beautiful object. I see a book as something to be owned. Stimulating and possessive – these are the properties that books should have.

I also somehow think of a book as an object. This is a book called "GGG"[9] which I designed last year. It has a lot of text about old historical things and people really liked it. When it came to designing a historical context, the goal was to somehow make it fresh again, like an object.

Do you know what Talisman[10] is? Many societies have a special and sacred objects which have magical importance. Books are almost like this. Depending on whether you read a book in your 20's, 40's, 60's, when you fall in love or are heartbroken, each time it gives a different pleasure and meaning. Books are not static objects. They always change.

If you see a title called, "The Infinite Book" what do you imagine?

A Möbius strip? A black paper? This is "The Infinite Book" made by Timm Ulrichs[11]. It has two mirrors facing each other which create ever-repeating reflections. If you place the book on the table, you would see different mirror images depending on your seat. This is the principle of "the Infinite Book" which surprises by using materials that are not typical for books.

Would you take a look at this film? What you see is a collaboration together with Nora Schultz[12] and Michael Beutler[13]. We held a workshop with the students from a Fine Arts course. It was basically a workshop asking art students to document and reproduce their own works into a printed format.Through this process, each student designed a poster. Then we took the machine made by Michael Beutler, squashed all the posters together and collected them into one bundle. This sausage-shaped object was the final output.

It's a positive phenomenon to view books in terms of ownership. These changes have already existed since the 1980s. I believe books must have highly polished designs together with substantial materials, yet if you speak of "Independent Publications" in Korea, it seems to indicate the originality of the contents. I would also like to recommend the term, "Independent Publishing" be reconsidered. I prefer using "Small Press" because having the word "Independent" makes it seem too important. So I often say "Small Press" by simply referring to the scale of production.

Because the term, "Independent Publishing" has an ascriptive connotation, media views independent publishing is an interesting and bizarre phenomenon. But once the central media pays attention, it causes so many distorted facts that are completely alienated and distant from the reality. I believe we have to continue questioning the definitions of independent publications in terms of finding a new way to experiment as well as to adjust images and text from a different perspective.

The only aspect that we highlighted in Itta Project was "it is composed of people from publishing houses who donate their time and talents

to run the project". We thought this type of branding would draw attention from journalists in the field of Art and Culture. That's why we chose to use such big words such as "Labor-sharing Independent Book Project". In respect to choosing the words, I would also like to rethink how we refer to a book as an "objet" in Korea. It is a French word. Why can't we change this single word into Korean? Why don't we call a book simply a book?

This is a small wonder box published by William Copley[14] in 1968. He published six different issues of this book/portfolio under the title of "SMS". However, the meaning of "SMS" is not the one you would expect today. It stands for "Shit Must Stop". It's a fantastic work because it is not a book with a typical binding but a collection of small objects. It also has a plan description of how things were arranged. The book contains various works – a piece made up with the phrases found in a dictionary and a set of photos questioning, "what is the definition of a thing" – from world famous artists such as Man Ray[15], Marcel Duchamp[16], Robert Rauschenberg[17] and more. As you know, many artists in the 60's tried to look for new sites,

forms and formats beyond the limitations of the space. One of the forms that received attention at the time was periodicals. While some stuck to printed mediums, others pushed them to the limit. "SMS" was the later case which endeavored to go across the boundary.

What we have to understand is that a book is no longer a book in the traditional sense. People who acknowledge the aspects – a book is now an artistic object as well as a souvenir which can be appreciated and certified – seem to become self-initiative and to make the best outcomes. Though books can go out of stock, because it's a three di-mensional object which can be collected and kept to recall memories, independent publishing contin-ues by the people who value these qualities.

미스 리드

2009년 처음 열린 미스 리드(Miss Read)는 오늘날 베를린의 대표적인 아트북페어로 자리 잡았다. 우리가 방문한 2016년에는 베를린의 문화기관인 예술아카데미(Akademie der Künste, Berlin)에서 열렸는데, 개인 제작자에서부터 정기 간행물과 예술 전문 서적을 제작하는 출판사까지 약 200여 팀이 참가했다.

삼일 동안 진행된 북페어의 부대행사로 워크숍, 대담 형식의 강연, 퍼포먼스가 열렸다. 이날 우리는 낭독 퍼포먼스와 리소그라피 연구 워크숍을 보고 스페인 독립출판의 성장에 대한 강연을 들었다. 강연은 마드리드 아트북페어의 공동 설립자와 큐레이터가 진행했다. 그들은 축소되고 있는 스페인 출판 시장에서 지난 7년간 꾸준히 성장하고 있는 소규모 독립출판과 그 원동력인 아트 북페어의 기능에 관해 설명했다.

미스 리드는 단순히 책을 사고파는 장터가 아니라 사람들의 만남의 장으로도 역할을 하고 있었다. 돈을 투자해 자신의 작업을 책으로 출판한 한 예술가는 큐레이터를 만나 전시 기회를 얻고, 서로 다른 나라의 소규모 출판사들은 각 나라의 인쇄소 정보를 주고받았다. 짐 가방에 책을 담아 북페어 일정에 맞춰 세계 여행을 다니는 제작자도 있었다. 이곳을 찾은 사람들은 책을 사고 파는 일보다 명함과 질문을 주고받는 일에 더 분주해 보였다.

Miss Read

Miss Read, first established in 2009, became the most prominent art book fair in Berlin. In 2016, the year we visited, it was held in the Akademie der Künste Berlin. From individuals to publishing houses dealing with periodicals as well as artist publications, about 200 teams participated.

This three-day book fair includes various workshops, lecture conferences and performances. Among them, we attended the recital, the risograph workshop, and a lecture that dealt with the growth of the independent publishing scene in Spain. It was presented by the founder and the curator of the Madrid Art Book Fair. They explained that Spain's publishing market had been reduced while the independent publishing scene had been constantly growing in the past 7 years, and in relation to this phenomena, underlined the role of art book fairs.

Miss Read is not just a market where people sell and buy books, but rather a new meeting place where an artist who invested money in publication of his works gets a chance to do an exhibition through a curator he just met, where small press houses exchange information about printing companies based in each other's country, and where a publisher carrying a suitcase full of books travels around the world according to book fair timelines. The people who visited the fair seemed to be more busy exchanging business cards than making quick money from their books.

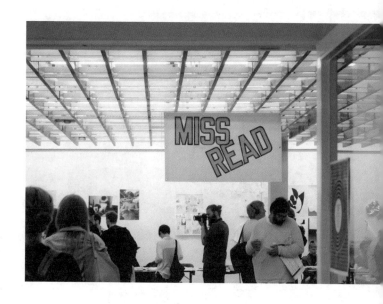

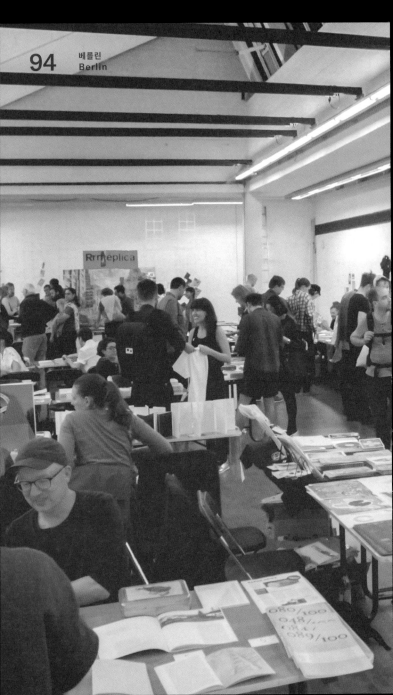

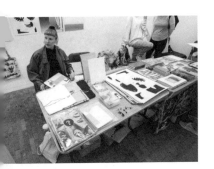

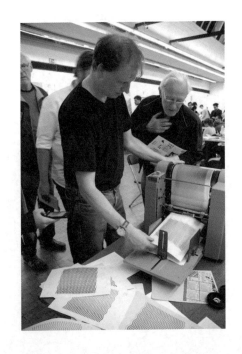

기성 출판과 독립출판

기성 출판사의 경우 그동안 습득한 여러 가지 기술, 즉 '이해를 위한 장치'를 많이 염두에 두죠. 책 뒷표지에 있는 추천사나 디자이너가 흔히 이야기하는 가독성, 혹은 실제 저자와 만나 책의 텍스트에서 빠진 링크를 채워주는 북 콘서트도 그들이 가진 기술 중 하나죠. 이러한 방식으로 독자를 놓치지 않는 다양한 기술을 숱하게 마련해두고 그것을 여러 가지 방식으로 재생산하기 마련인데 독립 출판물은 그런 게 없죠.

독립출판 프로젝트를 시작하게 된 계기는 제가 원하지 않는 책을 만들어야 한다는 것과 판매 부수에 대한 책임감 때문이에요. 상사가 명령을 내리면 그 책을 책임지고 편집하게 되는데 이 과정에서 오는 피로가 컸어요. 제가 기획을 몇 차례 했었지만 판매 부수 등에서 잘렸어요.

상업 출판이 매너리즘에 빠질 수밖에 없는 이유는 무언가 시도할 수 있는 시장이 아니기 때문이에요. 그 틀에서 벗어나면 규모가 작아지고 상업적 구매력은 줄어들지만 독립출판과 같은 작고 협소한 소비층이 형성되는 것이죠. 한국도 시장이 점점 다양해지고 결이 나뉘고 있기 때문에 독립출판은 계속 성장할 것이고 기존의 대형 출판사는 나락으로 빠질 수밖에 없어요.

 독립출판이 주목받는 것은 출판계의 흐름을 벗어나고 싶은 사람들이 많아서 그런 게 아닐까 싶어요.

기성 잡지 안에 있는 것들을 보면 거의 광고예요. 콘텐 츠인 듯 보이지만 제품과 광고가 꼭 들어가요. 이러한 정보를 보기 위해 잡지를 들춰보는 사람들도 있겠지만 전 상 대적으로 위축될 수 있다고 느꼈어요. 이걸 한번 비틀면 재밌는 책이 나오지 않을까 싶었어요. 그래서, 첫 잡지에 "돈이 많지 않은 사람들도 약간의 위안과 우쭐함을 느끼는 동시에 휴식을 느낄 수 있는 잡지"라고 설명했지요.

일반적인 대형 시장이라면 당연히 두각을 나타낼 수밖 에 없는 '학습과 실용'이라는 측면이 독립출판 시장에 는 완전히 삭제돼 있는 거죠. 때문에 '책'이라는 것은 어떤 식으 로든 쓸모를 가져야 한다고 판단하는 큰 시장과는 사뭇 다른 목 소리가 나올 수 있는 거예요.

독립출판이라는 것이 '타인의 간섭이나 승인 없이 자 신의 책을 만든다는 것'이잖아요. 많은 사람이 이러한 방식으로 자신의 목소리를 내는 건 나쁘지 않다고 생각해요. 좀 많아지긴 했지만요. 요즘엔 자기만족으로 끝나는 책도 많아졌 어요. 자기 목소리를 내는 건 좋지만 이걸 발전시켜 더 좋은 책을 내는 것이 바람직할 것 같아요.

독립출판물의 과열인 현대사회 아니겠어요. 개성의 각축전이랄까? 디자인이나 개인의 사소한 감정들이 과잉돼 나오는 독립출판물이 종종 있지만, 저희는 같이 놀자는 것이 목표예요. 한 명의 개성을 위해 남이 희생된다면 절대 같이 놀 수 없거든요. 때문에 개성이나 자존감을 위해서라기보다 같은 목표를 향해서 갈 수 있는 위대한 작품을 가지고 책을 내고 싶었어요.

주위 사람들은 독립출판은 집단현상이라고 말해요. 사진 위주의 책들이 많고, 외관상 모두 비슷해 보여요. 독특한 성격을 가진 책을 찾기는 쉽지 않죠. '이 방법이 더 성공적'이라고 말하긴 어려운 것 같아요. 일시적 유행같은 거죠. 3년 뒤에 없어질지 누가 알아요.

Small Press and Big Publishing

In the case of big publishers, they pay more attention to various types of acquired techniques, so called "devices for understanding". Some of these include testimonials on the back cover, legibilities – an issue that commonly appears among designers – or book concerts which provides opportunities to meet the actual author and to fill in missing links from the original text. Big publishers try to keep their customer by applying and reproducing such techniques, yet independent publishing doesn't have such things.

I self-initiated an independent publishing project firstly, because I could no longer bear the pressure to make a book that I didn't want to and secondly, because there was too much responsibility for the number of sales. Once the boss gave an order, I had to take full responsibility on the editorial part of the book. For me, this process was extremely tiring. There were a few times that I took charge of planning but in the end, everything got rejected due to the expected number of sales.

The reason why commercial publishing falls into mannerism is because it's not a market where you can try something new. Once you step out of this boundary, the scale and sale gets reduced yet you get a new range of minimal consumers – like independent publishing. Because Korean book markets are now getting more and more diversified and subdivided, pre-existing publishers like big publishing houses are perpetually thwarted.

Independent publishing gets more of the spotlight perhaps because there are increasing numbers of people who want to move away from a dogmatic approach of traditional publishing.

If you take a look at commercial magazines, they are full of advertisements. It seems as if they are part of the contents but in fact, they always have these products and ads. Maybe some peek through magazines to see this information but I thought it could possibly make readers feel intimidated. I thought magazines could be more interesting if I twisted these elements a little. So I introduced my first book as "a zine provides a bit of comfort while making you feel flattered and relieved even for those who live from hand to mouth".

In independent publishing, the aspects of "learning and practicality" – the most notable features in big book markets – are completely removed. This is what creates a variety of voices that are different from big publishers who believe books must be useful.

Independent publishing is about "making your own book without interference or approval from others". Although now we have too many of them, I don't think it's a bad thing to use this method to raise one's own voice. Lately, there are a lot of books that are merely for personal-satisfaction. It's a positive thing to let one's own voice out, but making further improvement to create a good book seems more desirable.

Today's society is overheated with independent publications as if they are having individuality competitions, isn't it? Some publications present excessive designs or trivial feelings but our aim is to play together. You can never play together if one has to sacrifice for the other's character. So for us, it's not about individuality or self-esteem, but about reaching towards the same goal through publishing literary valuable books together.

People around me say independent publishing is a mass phenomenon. Appearance wise, they look very similar to each other and often have a lot of photos. So it's difficult to find books with special characters. I don't know which approach is more successful. It's like a boom. Who knows it might be over in three years.

아트북과 독립출판

 짧게 설명할수록 오해받는 카테고리를 최대한 간략히 정의하라는 말은 폭력적일 수 있어요. 그중 하나가 독립출판인데, 독립출판 안에는 너무나 많은 요소가 혼재돼 있기 때문에 그 속에서 무엇을 택할 것인지가 더 문제이지, 이 혼재돼 있는 씬을 뭐라고 정의할 것인지, 어떻게 분류할 것인지는 개개인에게 맡겨져 있어요.

독립출판물의 경우 책을 완성하는 기술의 측면이 달라서 이러한 기술을 어떤 분류에서 어떻게 보느냐에 따라 다를 수 있어요. 그래서 정의를 내리는 즉시 다음 달에 틀릴 확률이 높아지는 편이에요. 시기별로 판단할 수도 있지만 내일 당장 바뀔 가능성이 있는 분류이죠.

저는 아트북과 독립출판 역시 명확하게 구분할 수 있는지에 대한 의문이 크고, 명확하게 나누라고 한들 그것이 무슨 소용이 있나 싶어요. 굳이 나눈다면 아트북은 좀 더 시각적인 면에 치중한 책이라고 할 수 있겠지만 그것 또한 독립적인 형태로 발행되기 때문에 상위 개념에서 독립출판물이라 얘기하곤 하죠.

독립출판이라는 것이 어디다 가져다 붙이려면 얼마든지 붙일 수 있는 거 같아요.

자신의 목소리, 의지가 더 강하게 반영된 책이 독립 출판물 아닐까요?

독립출판물의 기준 자체가 모호하니 기준을 나눈다는 행위 자체도 이상한 거죠. 출판사가 있다고 독립출판물이 아니라고 말하기도 모호하고, 독립출판물이지만 이천 부넘게 뽑는 책도 있고, 오히려 일반 출판물의 판매 부수를 넘어서기도 하니 그 기준이 매우 애매해요. 그래서 저는 독립 서점에 있는 모든 책을 독립출판물이라고 생각해요. 그림만 잔뜩 있는 책은 사실 아트북에 가깝잖아요.

아트북과 독립출판물의 결은 분명히 달라요. 개인적으로 독립출판이라는 말을 별로 좋아하지 않아요. 아무렇게나 재밌게 하자는 뉘앙스도 없지 않아 있고... 행위 자체는 높이 평가하지만 한국의 경우 전체적인 내용과 형식이 해외에서 '아트북'이라고 불리는 것들과의 수준 차이가 상당해요. 우리가 생각하는 아트북, 독립출판물은 책의 느낌보다는 문구의 느낌이 좀 더 강한 것 같아요. 아직 '아트북'이라는 말을 그렇게 많이 쓰지 않기도 하고요.

또 해외의 경우 '독립'이라는 말을 거의 사용하지 않아요. 작년에 언리미티드 에디션 7회에서 '아트페어'라는 말을 처음으로 내걸었지만, 그것은 미술관에서 페어가 열리다 보니 어떤 논리성이나 근거가 필요해서 그런 것으로 생각해요.

기관마다 아티스트 북을 이해하는 맥락이 달라요. 만약 네 기관의 사람이 모여서 이야기를 한다면 각자 초점을 두고 있는 아티스트 북에 대한 다섯 가지 개념이 나올 거예요. 저희의 경우, 개념적인 아티스트 북을 포함한 모든 예술 출판물을 수집하는 기관이에요. 이 말은 책 외에 신문, 잡지, 엽서, 포스터, 예술 음반과 오디오 카세트 등 정기 출간된, 단지 독특한 것에 그치지 않는, 더 넓은 독자층을 위한 모든 종류의 출판물을 다룬다는 얘기죠. 그리고 다른 기관에서 희귀한 책이나 오브제를 수집하듯이 저희도 수작업으로 제작된, 소위 '북 쿤스트(Buch Kunst)'라고 불릴 만한 고품질의 책도 있어요. 하지만 '아티스트 북'이라는 명칭 자체가 다양한 종류의 책에 쉽게 적용될 수 있기 때문에 저희조차도 이 분야를 명확한 단어로 정의하기가 어려워요.

그리고 저는 독립출판물과 아티스트 북 사이에 큰 차이가 있다고 생각하지 않아요. 물론 독립출판물은 소규모 출판사에서 제작하는 경우가 많지만 저는 이 모든 걸 오늘날 출판 문화의 한 현상으로 바라보고 있어요. 부피가 작아지고 손쉽게 제작 가능한… 이것이 아티스트 북인지 아닌지를 규정하기보다 시대의 흐름에 맞춰 변화하는 한 장면으로요.

예술가와 디자이너의 경계를 구분하는 것도 어려워졌어요. 저가의 책이더라도 예술 정신과 감각이 담겨있는지가 더 중요한 것 같아요. 물론 작업의 콘셉트는 작가가 가지고 있지만 책을 제작하는 과정에서 디자이너와 협업하기 때문에 그 경계를 구분하는 것 또한 점점 더 어려워질 수밖에 없고요.

저희 스튜디오에 있는 대부분의 책은 디자이너와 아티스트의 협업을 통해 만들어졌어요. 이건 저희가 제작한 『중력에 대항하는 야생』[18]이라는 책이에요. 근본적인 아이디어는 양혜규의 전시 작업과 그 과정에서 파생된 이미지를 혼합하는 것이었어요. 새로운 이미지가 기존의 작업과 결합하면 독자는 지금 보는 것이 그녀의 작업인지 아닌지 알 수 없게 돼요. 결국 이 책이 저희 벽지 시리즈의 시발점이 돼 양혜규[19] 작가의 설치 작업 일부로 전시됐어요. 전시가 끝난 후에도 그녀는 이 벽지를 작품 배경이나 전시작품으로, 또는 새로운 작업과 결합해 사용했어요. 한 권의 책이 어떻게 설치 작업의 형태로 확장될 수 있는지 보여주는 좋은 예지요.

Art Books and Independent Publishing

It's a bit abrupt to ask for clear definitions of the categories that can be misunderstood easily when they are explained in short sentences. One of these categories is independent publishing because it is multidimensional. It consists of a wide range of things that are merged together. What matters is to choose the one that's relevant for oneself. So how to define or categorize this scene is really up to each individual.

In other words, in case of independent publications, the definition can vary in terms of how you classify the techniques that are executed to complete the book. Therefore, once you make a set answer, there is a higher chance to get it wrong the next month. You can modify definitions periodically, but it's still one of the categories that can fluctuate the next day.

I doubt if it's possible to make a clear distinction between art books and independent publications. Even if we do, what does it matter? If it's really necessary, I would say art books focus more on visual aspects. But because they are distributed in the form of independent publishing, we call them in-

dependent books as they belong to the generic category of independent publications.

You literally can call any type of books, "independent publication".

I think independent publications seem to have a greater reflection on one's voice and individuality, no?

It doesn't make sense to set a clear criteria when the criterion of the independent publication itself is ambiguous. It's ridiculous to say, "this book can't be called an independent publication because it's produced by a publishing house". Because there are many independent books printed, more than 2,000 copies, and sometimes these books sell more than regular publications, it's difficult to fix the standard. So I consider all books belong to independent bookshops, independent publications. Books full of images are more likely art books.

The nature of an art book and an independent book is definitely different. Personally, I'm not a big fan of the term, "Independent publishing". It has a subtle nuance of simply having fun re-

gardless of the outcome. I respect the action itself but in the case of Korea, there is considerable difference in terms of styles and contents between what is so called "art books" overseas. The concept that we currently have about "art books" or "independent publications" feels more like a catchphrase rather than the type of book itself. People also don't use the term, "art book" that much.

In other countries, it's rare to see people using the word, "independent" in this scene. Although last year's 7th Unlimited Edition employed the term, "Art Book Fair" for the first time, I believe they did this because they needed to have some sort of logic or reason for hosting the fair in the location of an art museum.

Different institutions have different concepts about artist books. If there were four people in this room, there would be five different concepts in which each person has his focus. For us, we are the center for all types of artist publications including conceptual books. This means, we not only collect artist books but also newspapers, magazines, postcards, posters, records and audio cassettes that are published more than once. These works are not just unique but have the purpose of being shared

with wider audiences. As other centers collect exclusive books and objects, we also have handmade books, so called "Buch Kunst", which are high quality. But it is also difficult for us to define this category because it's really easy to say "artist book" to every kind of book.

I think independent books are not necessarily different from artist books. Of course independent books are often created by small publishers. But I view it as a phenomena of how books are published nowadays. Smaller volumes and easier productions... It's not so much about whether this is an artist book or not, but more about the whole scene that changes throughout time.

Now it is also hard to find the border between artists and designers. What's important is to have an artistic spirit even if the book is cheap. Of course, it could be an artist who has a concept but because today, many artist collaborate with designers, it gets more and more complicated to define their roles.

The majority of books in our studio are the result of collaborations between artists and designers. One is called, "Wild Against Gravity"[18] which we collaborated on with the artist, Haegue

Yang[19]. The basic idea was to blend pictures of the artworks with different image surfaces that were derived from her working process. When the new images are combined with the existing artwork, readers are no longer able to understand if it's her work that they are looking at. In the end, this book became a starting point of the wallpaper series which was exhibited as part of Haegue Yang's installations. Even after the exhibition, she continued to use the different wallpaper as a backdrop of another installation and as a part of her work itself. This is a good example showing the extension of how a book can grow into an installation.

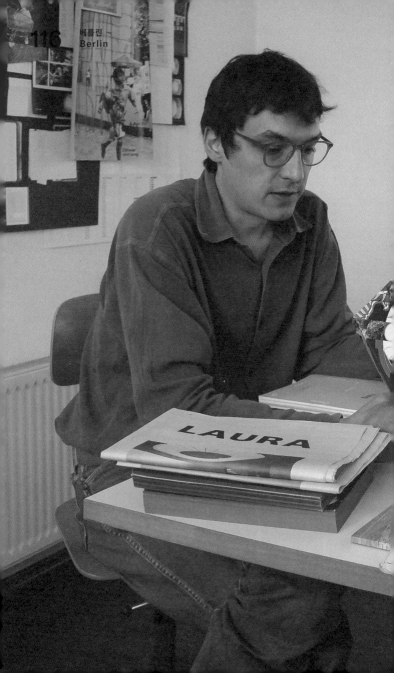

기록의 용도

역사적인 맥락에서 보면 책은 항상 공동의 소유물로 존재해왔어요. 과거의 기록물과 인쇄물 대부분 여러 사람이 공유하는 방식이지 않나요? 책이 개인의 소유물로 탈바꿈하기 시작한 건 겨우 150년밖에 되지 않아요.

이건 2015년 사르자 비엔날레[20]에 출품된 양혜규의 작업을 담은 『불투명한 바람』이라는 책이에요. 장소 특정성이 강한 작업이었기 때문에 책으로 출판하기로 했죠. 설치 작업의 특성상 전시가 끝나면 똑같은 작업은 어디에서도 찾을 수 없거든요. 순전히 기록을 목적으로 한 책이에요. 기록을 해두면 실제 전시를 방문할 기회가 없었던 사람들도 책을 통해 그녀의 작업을 접할 수 있잖아요.

6,70년대엔 예술 활동이 대부분이 페인팅, 드로잉, 혹은 조각과 같은 보편적인 결과물로 한정되지 않았기 때문에 이 시기의 출판된 책들은 굉장히 중요해요. 이를테면 풍경화가가 자연을 거닐며 수집한 돌멩이를 특정한 형태로 배치하는 것을 기록한 책이 작가의 활동에 대한 정보인 동시에 개별적인 예술 작품으로 인정받았어요.

또 다른 예를 들어보죠. 이들은 3명의 예술가로 구성된 70년대 미국의 게릴라 아트 액션 그룹[21]이에요. 이들은 '부유층을 위한 투자 도구로 이용되는 예술계에 더는 있고 싶지 않다'고 했어요. 이들이 기획한 가장 유명한 해프닝[22] 중 하나는 혈액 목욕(Blood Bath)이에요. 두 명의 남자와 여자가 뉴욕현대미술관 로비에 들어가 피범벅이 돼 쓰러질 때까지 싸웠어요. 경찰이 왔을 때 그들은 마치 아무 일 없었다는 듯 일어나 전단을 뿌리고는 홀연히 사라졌어요. 이들이 남긴 전단에는 당시 뉴욕현대미술관의 이사회였던 록펠러[23] 가문이 베트남 전쟁에 쓰이는 무기 제조에 가담하고 있다는 주장과 함께 그들의 사임을 요구하는 내용이 담겨 있었어요. 재미있는 건 이들이 해프닝을 벌이기 전, 언론에 이러한 계획을 미리 알렸다는 사실이에요. 만약 이러한 사건이 글과 사진을 통해 기록되지 않았다면 우리는 이 사건에 대해 알지 못했을 거예요.

이건 브라질 출신의 그래픽 디자이너 로제리오 두아르테에 관한 책이에요. 마리아나 카스티요 데바[24]와 함께 장장 4년에 걸쳐 작업한 자체 기획 프로젝트죠. '트로피칼리아'라고 들어보셨나요? 트로피칼리아는 간단히 말하면 60년대 후반 유럽의 록 음악이 열대지방 문화로 이입되며 발발한 브라질 문화 혁명이에요. 이 운동은 인쇄 매체를 기반으로 브라질의 정체성과 록, 그리고 사이키델릭 음악을 부흥시킨 중대한 사건이죠. 로제리오는 이 시기에 카에타노 벨로조[25], 질베르토 질[26],

갈 코스타[27]를 포함한 많은 예술 운동가를 위한 디자인을 한 사람이에요.

그는 포스터 외에도 시와 카에타노와 질베르토가 부른 많은 노래의 가사를 썼어요. 또 시네마 노보[28]의 선구자인 브라질 영화감독 글라우버 로차[29]와 협업하며 그의 작품과 관련된 많은 디자인 작업을 담당했죠. 로제리오는 연기, 시, 음악, 로고와 잡지를 통해 고문에 반대하고 대항하는 반체제적 이벤트를 기획하는 등의 60년대 브라질 반문화운동 중심에 있던 사람이에요. 그 자신도 독재정권 시절 많은 고문을 받고 예술 활동을 전면 금지당하기도 했고요.

하지만 정작 그에 관한 책은 몇 권 없어요. 시집과 그의 그래픽디자인 작업을 담은 작은 책자가 전부죠. 로제리오는 수학과 색채에 대한 이론도 여러 번 발표했지만 여태껏 그의 다양한 작업을 한 권으로 엮은 책은 없었어요. 그래서 저희는 브라질 북동부에 홀로 고립돼 살고 있던 그를 찾아 나서기로 했죠.

로제리오를 만난 후 그의 작업을 다시 모으고 기록하는 일을 했어요. 그가 소장하고 있지 않은 작업과 앨범은 사비를 들여 구매했어요. 그가 썼던 시를 최초로 영문으로 번역하고 4년간 그의 작업을 한 권의 책으로 엮어내는 데 매진했어요. 그동안 인쇄비와 출판비, 전시를 위한 기금도 마련했고요. 전시는 프랑크푸르트에 이어 브라질에서도 이루어졌어요.

안타깝게도 그는 한 달 전 세상을 떠났어요. 그가 세상을 떠나기 전에 역사적으로 중요한 위치에 있는 그를 발굴하고

그의 작업을 기록한 건 디자이너로서, 그리고 저 자신에게 매우 의미 있는 일이에요.

Purpose of Archiving

From a historical perspective, books have always been collective objects. For most historical records and prints, it was always many people sharing one document, right? It's only the last 150 years since printed books have become individual antiquities.

This is "An Opaque Wind", a catalogue for Haegue Yang's installations exhibited in the Sharjah Biennial[20] 2015. We brought out this book as a documentation because her work was very site specific. The same arrangement would no longer exist once the installation was taken down. So the sole purpose of this book was to keep the moment because when it is documented as a book, it's possible to show her work for those who didn't get an opportunity to visit the exhibition site.

Books throughout the period of the 60s and 70s are very important because artists' works or activities did not always result in classic mediums such as painting, drawing, or sculpture. For instance, a book documenting the activities of a landscape art-

ist – whose artwork was to wander in nature and put collected stones in a certain form – provided information about the actions but at the same time, was considered as an artwork on its own.

GAAG(Guerrilla Art Action Group) [21] is another example. This group consisted of three artists from the 70's in America. They claimed "we don't want to be in this art scene where the art is just an investment for the rich and functions like an economy". One of the most famous happenings they planned was Blood Bath. For this happening [22], the two men and women went into the foyer of MOMA(Museum of Modern Art), wrestled until they collapsed and were covered in blood. When security came, they got up as if nothing had happened and left behind flyers. The flyer had a manifesto accusing the Rockefeller [23] family involvement in manufacturing weapons for the Vietnam War and calling for the resignation of the family members from the museum's trustee board. What's interesting is before they made the Blood Bath, they informed the press in advance. If this event was not documented in the form of texts and pictures, we would still not know about this event.

This book is about a Brazilian graphic designer, Rogério Duarte. I worked on this book for four years together with Mariana Castillo Deball[24]. So... do you all know what Tropicália is? It's basically a cultural revolution that happened in Brazil during the 60s. It was triggered by the course of adopting European Rock music into the tropical context. This was a significant event because it revived Psychedelia, Rock and most importantly, Brazilian identity on the basis of printed matters. Rogério is a person from this period who did a lot of designs for such musicians as Caetano Veloso[25], Gilberto Gil[26], and Gal Costa[27]. Besides designing posters, he also wrote many poems and lyrics that Caetano and Gilberto sang. In addition to that, he was responsible for many designs related to the Brazilian film director, Glauber Rocha[28] who was a pioneer of Cinema Novo[29]. Rogério was indeed a central figure in the counterculture of 60s' Brazil. Through acting, writing poems, creating logos and magazines, he organized events that were against governmental authorities' actions, especially torture. He himself was tortured during the military dictatorship and his activities were banned for a while.

Despite these facts, there have been a few books written about him. Even these books are just collections of poems or small booklets about his graphic design. He even published several theories about mathematics and colors, but these achievements have never been collected as one book. So we decided to go and interview him. We found him living an isolated life in the Northeast of Brazil.

After we met him, we started to collect and document his works. We had to cover some of the works and albums that he didn't have anymore. So what we basically did for four years was to focus on transcribing his work. During this period, we translated his poems into English for the first time and also found funding to print and publish the book. Then the exhibition was held in Brazil after the one in Frankfurt.

Sadly, Rogério died a month ago. However, it still remains as a meaningful experience for me to find a man who's historically significant and to share his works with a wider public before his death.

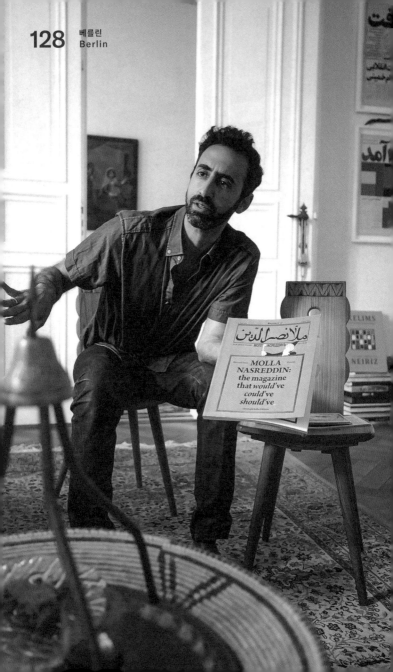

저자와 독자

제 책을 보는 사람들은 기준이 불확실한 불특정다수예요.

 불특정 '소수'가 아닐까요? 필요한 이야기만으로 채워진 시장에서 박탈감을 느끼는 극소수의 수요자.

 저는 독자보다 작가를 우선으로 생각해요. 그래서 작가의 의도를 수동적으로 반영하기보다 더 매력적인 꼴을 만들기 위해 꾸준히 소통해요. 독자가 작가의 작품을 보다 풍성하게 관람할 수 있도록요.

예술가의 입장에서 작품의 위계를 나눈다면 책이 최하의 위치에 있어요. 그들에게 책은 단순히 기록물, 카탈로그, 마케팅의 용도로 사용될 뿐이에요. 전시를 하면 작가는 일종의 마케팅 수단으로 사진 촬영과 글을 의뢰해요. 하지만 저희 입장에서 책의 위치는 정반대예요. 작가가 만든 비싸고 아름다운 작업은 결국 사람들이 책을 새로운 시각으로 다시 보게하는 도구일 뿐이죠. 우리는 책을 중심으로 모든 것을 구성해요. 그 이외의 것은 무대 미술이나 연극 세트장에 쓰이는 소품과 같아요.

개인적인 느낌보다는 읽는 사람을 어느 정도 염두에 두고 만든 책이 좋은 책인 것 같아요. 자기만의 작은 목표가 있는 책이라면 더 좋고요.

타인의 눈을 신경 쓰고 만드는 콘텐츠는 오히려 더 소외당하기 쉬워요. 자기가 하고 싶은 말을 솔직하고 도전적으로 제시한 글이 더 인정받고 공감받는 것 같아요.

그것이 책이든 작업이든 혹은 조각품이든, 저희에게 가장 중요한 건 이러한 결과물이 관객을 새로운 방향으로 인도하는 계기가 되는 것이에요.

소장하고 싶은 마음이 강하게 든 잡지 중 하나로 『지극히 개인적인 잡지』가 있었어요. 너무 개인적이어서 '도대체 뭘 보여주고 싶은가?' 하면서도 한편으로는 매력적으로 느껴졌어요. 알 수 없는 에너지가 끌어당기는 느낌이랄까요.

'내가 왜 책을 만드는가?', '내가 왜 출판을 하는가?', '정말 이 내용이 책으로 담기에 적절한가?'라는 질문이 더 중요하다고 생각해요. 동시에 '그럼 어떤 형식의 책이 돼야 할 것인가?'라는 생각을 하게 돼요. 그러다 보면 실험을 하게 되니 책이 난해해지기도 해요.

독립 출판물을 찾는 독자가 일반적으로 1,000 - 2,000 명 정도예요. 이들은 '이게 뭐지?'라는 감정을 불편하게 여기지 않는 사람들이에요. 이를테면 혼란스러움, 바로 판단하기 어려운, 불편함, 거리 두기 필터링하기, 방해되는 장치, 빙빙 돌아가기 등 일반적으로 행해지지 않는 기술을 구사하는 예술품, 책, 또는 작품을 즐기는 층인 거죠. 이들이 독립출판물을 찾는 이유는 간단해요. 일반적으로 행해지는 기술에 매료되지 않기 때문이에요. 읽기 어려운 것을 즐기는? 어쩌면 약간 난해하거나 무서운, 일상생활의 얇은 공포를 즐길 수 있는 부류의 사람들, 자기를 괴롭히기 좋아하는 사람인 거죠. 자신이 너무 소중해서 이해하기 어려운 텍스트로 본인을 괴롭히는 사람들이 있어요.

저희가 출판하는 책을 선정하는 관점은 '이 한 권의 책이 내 인생을 바꿀 수 있는지'예요. 저는 한 권의 책 때문에 독일로 갔다가, 한 권의 책 때문에 프랑스로 옮겼고, 결국 또다시 한 권의 책으로 인해 한국에 돌아올 생각을 했어요. 예술이나 문학작품을 보고 한번 무너져본 사람은 그걸 계속 찾게 돼요. 다른 사람들에게도 그런 기회를 만들어주고 싶었어요. 저희가 고른 책 안에는 한 사람의 정체성, 개성을 무너뜨릴 만큼의 힘이 있다고 믿어요.

 저는 다수의 책을 대충 속독하기보다 소수의 책을 반복해서 봐요. 매력적이지만 이해하기 어려운 책을 반복적

으로 볼 때 비로소 보이는 지점, 그것이 어쩌면 불친절한 독립출판의 최대 매력이에요. 독립출판물은 어떻게 보면 이러한 불친절한 기운을 모아 책 자체를 신성화하는 것이에요. 독립출판물의 이러한 특성을 알고 있기에, 저는 텍스트를 반복해서 읽고 접근하는 편이에요. 그리고 이해가 안 되는 책은 보류해놔요. 이것이 제겐 굉장히 중요한 태도예요. '싫다'라는 말 대신 '모르겠다'는 말을 쓰는 것. '보류'는 표명을 안 하는 거예요. 좋다, 싫다는 판단을 서둘러 내리면 그 책의 가치가 고정되어 버리는 경우가 많지만, 보류 카테고리에 넣어두었을 때는 몇 년 뒤에 취향의 변화, 논리의 변화, 사고의 변화로 그 책의 가능성을 다시 볼 수 있다는 생각이에요. 저는 더 고립되고 특이한 요소가 많은 책이 나와서 그들이 더 주목받았으면 좋겠으나, 그렇게 안 되더라도 상관없어요. '이러한 방향으로 가야 합니다'라고 해서 그 방향으로 가는 건 이 씬의 매력이 아니라서요. 지향하는 방향의 반대 것들이 나와야 이 현장이 무너지고, 흩어지고, 모이고 하는 거예요.

Author and Reader

People who read my zines are unspecified multitudes with no fixed criteria.

 I would say unspecified "minorities" – A minimum number of people who feel deprived of the market filled with practical contents.

I put priority on the authors rather than the readers. So instead of reflecting the author's intentions in a passive manner, I constantly communicate with him or her to make a more fruitful output. This attitude eventually provides a richer experience for the readers as well.

If we divide hierarchy of works from the viewpoint of an artist, books would be in the lowest place. For artists, books are just documentations, catalogues and a means for marketing. When they have an exhibition, they commission someone to photograph and write about their work – It's just a way of marketing. But for us, it's the opposite. All those expensive and beautiful works are tools to bring people back to the book. The book is really the

center and the rest are like props in a scenografie or theater set.

I view good books as the ones that are made in consideration of the targets rather than personal feelings.

Self-conscious contents are more likely to be neglected. Challenging texts which speak for one's honesty are the ones that achieve higher recognition and draw more sympathy from the readers.

One of the magazines that really made me want to "have" was called, "Awfully Personal Magazine". It was too personal, to the point where I thought "what is this person trying to present". Despite that fact, I was held hostage to the contents as if there was some kind of unknown forces pulling me in.

Whether it is a book, project or sculpture, what's most important for us is that they always lead you somewhere else and never become an end point.

Having such questions of "why do I make a book", "why do I publish" and "is this an appropriate content to make into a book?" is more important. Once these questions arise, then you start to think, "what would be the right form for this book?". And sometimes the book becomes convoluted because you make experiments to get answers to this question.

The estimated number of readers for Independent publications are about 1,000 to 2,000. These are the people who don't feel uncomfortable with contents that evoke them to think "what is this?". In other words, they are the type of people who enjoy art work, books or projects which use skills – confusing, discomforting, distancing, filtering, obstructing, beating around and impairing instant judgement – that are unusual in general. One reason for them to seek independent publications is simple – they are not attracted to common techniques. These people bother themselves by taking pleasure from difficult or esoteric contents, a slight fear of daily lives.

 "Could this book change one's life?" – this is our motto to choose books for publishing.

I moved to Germany, then France and decided to come back to Korea because of the influence of the single books. People who are shattered by arts or literature constantly search for the same thing. For the exact same reason, I started to read books and wanted an opportunity to self-publish. I believe books we publish have power to shatter one's individuality as well as identity.

I prefer reading a small number of books over and over rather than skimming through many books. The fascinating thing about independent publishing is even if the book is attractive yet difficult, you can reach the point of realization by rereading the book. Independent publishing is some how about gathering these unkind energies to sanctify a book itself. Because I know these characteristics of independent publications, I tend to approach texts by reading them multiple times. If I don't get it, I put it off. This attitude is very important for me; Saying "I don't know" instead of "I hate". "Putting it off" means not expressing. If you hurry making decisions of yes or no, the value of the book is more likely to be fixed, but if you put it on hold, you can reevaluate the book as your taste, logic, or thought changes.

I would like to see more books that are unique and different. I wish these books would get more attention but I don't mind even if they don't. Going a certain direction simply because someone insists "this is the right direction" is not the virtue of this scene. This scene continues to collapse, disperse and come together when there are things opposite to each other.

Wie lässt es sich
Träumen in einer Strasse,
die nie schläft? Es soll
die erste Publikation über
die Feldbergstrasse in
Kleinbasel entstehen.
Mit Fokus auf Diversität
und alltagskulturelle
Themen – von der Strasse
für die Strasse.

68 / 100

FELD
BERG
STRASSE

Workshop task
4. Result discussion
5. Optional – Book store visits

facebook.com/feldberg
instagram @feldberg
feldbergzine@gmail.

펠트베르크 슈트라세

이른 아침, 우리는 펠트베르크 거리에 있는 카페로 향했다. 카페
테이블 위에는 'Ana with BB2'라고 쓰인 쪽지가 놓여있었고,
검은색 코트 차림에 비니를 눌러쓴 아나 브랑코빅이 우리를
기다리고 있었다. 아나는 펠트베르크 진(Feldberg Zine)
이라는 독립출판물의 기획자로, 그녀가 4년동안 거주했던 바젤의
펠트베르크 슈트라세를 소재로 잡지를 만들고 있었다. 잡지
내용은 국적과 전공이 다양한 사람들로부터 글, 사진, 드로잉을
받아 이루어진다고 했다. 우리는 이날의 워크숍을 통해 펠트
베르크 진에 직접 콘텐츠를 제공하고, 그 과정과 결과물은
BB프로젝트 출판물에 담기로 했다. 우리는 독립출판 현장을
경험할 기회였고, 아나에게는 새로운 협력자를 만나 콘텐츠를
얻을 기회였다. 이날 모인 장소가 펠트베르크 거리에 위치한
카페였던 것도 이러한 이유에서였다. 아나는 워크숍의 첫 번째
과정으로 펠트베르크 거리를 탐방해보는 것을 제안했고, 우린
샌드위치로 허기를 달랜 후 곧장 밖으로 나갔다.

거리 탐방은 소재 수집을 위해 진행되었다. 펠트베르크 거리는
빠르게 걸으면 10분 안에 한 바퀴를 둘러볼 수 있는 작은 거리
였다. 그렇지만 우리는 찬찬히 30분 정도 거리를 살펴 보며 사진을
찍거나 물체를 수집한 뒤 카페에 돌아와 드로잉을 하기로 했다.

거리로 나서자마자 우리는 약속이라도 한 듯 골목 사이사이로
흩어졌다. 생소한 풍경 속을 거닐며 사진을 찍고 버려진 물건을
주우며 거리의 인상을 모았다. 그리고 약속된 시간이 되자 카페로
돌아와 재빨리 방금의 경험을 드로잉으로 기록했다. 골목의
풍경을 콜라주 하듯 이어붙여 스케치하는 사람도 있었고, 자신의
경험을 짧은 만화로 풀어내기도 했다. 같은 공간이 각자의
관심에 따라 다른 모습을 보여주고 있었다. 이렇게 오전 한때를
보낸 우리는 수집한 소재를 바탕으로 결과물을 만들기 위해
바젤디자인학교로 자리를 옮겼다. 바젤디자인학교는 당시
아나와 알렉스가 재학 중이던 학교로, 그곳에 마련된 회의실과
실기실을 오가며 워크숍을 이어나갔다. 우선 회의실에서 오전에
수집한 물건과 드로잉 사진들을 펼쳐 놓고 감상을 나누었다.
바닥에 떨어진 꽃, 빗물에 젖은 전단지와 뜻 모를 메모 따위를
보며 엉뚱한 오해와 온갖 추측들이 터져 나왔다. 평소라면 거들떠
보지도 않았을 물건들이 대부분이었지만, 이날 우리에게는
바젤의 한 거리를 상징하는 기념품이었다. 그렇게 우리는 수집한
재료들을 책상 위에 펼쳐 놓고 어떤 결과물로 끌어내면 좋을지
토의했다. 그리고 고민 끝에 드로잉과 주워온 물체의 형태와
질감을 살려 펠트베르크 거리의 이야기를 보여주는 양면 포스터를
만들기로 했다.

포스터의 앞면은 스캔한 드로잉과 물체를 이용해 펠트베르크
거리의 단편적인 인상을 재구성하여 표현했다. 뒷면은 실제 거리

풍경과 아나와 함께 찍은 사진을 배치하고, 워크숍 소개와
참여자의 이름, BB2와 펠트베르크 진의 웹페이지 주소를 넣어
이날의 워크숍을 기록했다. 인쇄는 실크스크린으로 앞면 먹 1도,
뒷면 컬러 2도로 세 가지 색상의 종이에 각각 인쇄했고 총
50장을 제작했다.

아나와의 워크숍은 외부 프로젝트에 직접 참여하여 독립출판이
어떻게 이루어지고 지속되는지를 관찰할 수 있는 기회였다.
이날의 경험은 BB2 프로젝트 출판물과 펠트베르크 진에 각각
기록하기로 했다. 이를 통해 우리는 서로의 작업에 콘텐츠를
제공한 동시에 책의 '지면'이라는 자원을 공유하여 자신의
프로젝트를 다른 문화권의 독자에게 알릴 기회를 얻은 셈이었다.
이러한 점에서 미루어볼 때, 앞서 진행한 프레시 프린트와의
협업은 세 학교-파주 타이포그라피 학교, 브레멘예술대학,
바젤디자인학교-의 학생들이 제작한 책을 모아 하나의 단체를
만들고, 함께 북 페어에 참가하는 것이 목표였던 반면, 아나와의
협업은 두 프로젝트가 만나 공동 콘텐츠를 생산하고, 상대의
책에 자신의 프로젝트를 소개하며 개별활동을 지향했다는
점에서 차이가 있었다. 방식은 각기 다르지만 두 워크숍 모두
소규모 출판의 악조건-기성 출판에 비해 적은 자본과 좁은
유통망-을 힘을 모아 극복하려 했다는 점에서 의미가 있었다.
이렇게 '길 위의 멋짓' 동안 뭉쳤다 흩어지는, 게릴라성 협업을
통해 독립출판물이 따로 또 같이 살아남는 방법을 함께 고민해
볼 수 있었다.

Feldbergstrasse

Early morning, we headed to a café located
on Feldbergstrasse. On the café table,
a note was placed saying "Ana with BB2",
and Ana Brankovic—wearing a black coat
and beanie—was waiting for us. Ana was the
director of "Feldberg Zine", a self-
publication about the Feldbergstrasse in
Basel, where she once lived for four
years. Content for the zine, such as pho-
tos, drawings and writings, was provided
by people with different nationalities and
professions. Our purpose was to partici-
pate in the Feldberg zine through a work-
shop and later to document its process
and our experience in the BB2 publication.
It was an opportunity for us to capture
a site of independent publication and for
Ana as well, a chance to meet new collabo-
rators who would contribute additional
content for her zine. Meeting in the café
on Feldbergstrasse was also for this rea-
son. For the beginning of the workshop,
Ana suggested to explore the street first.
After having brunch together, everyone
quickly got up for the next step.

Exploring the street was meant for col-
lecting visual materials. Feldbergstrasse
was a small street in which one could look
around within 10 minutes. But we planned
to have a 30-minute stroll for taking
pictures or collecting found objects, and
to come back to the café for quick sketches.
Soon after stepping out of the door, every-
one scattered into the alleys and docu-
mented their impressions of the street
through a given method. 30 minutes passed,
we were back to the café once again, and
translated the experiences into drawings.
Some created images by putting fragments
of landscape together as if they were
making collages, and others through story-
board-like cartoons. The same street ap-
peared differently according to each one's
own perspective. After spending the morn-
ing collecting visual materials, we moved
on to the Basel School of Design to de-
velop these items.

The Basel School of Design was a place
where Ana and Alex were enrolled as
students. Moving back and forth between
seminar room and studio, we continued
the workshop. We spread the found objects
and the drawings on the table and shared

our thoughts and feelings about them.
While looking at the flower picked from
the road, the flyer soaked in the rain
and the piece of paper written in an un-
known language, all kinds of strange
guesses burst out. Normally they would
have been meaningless objects, but this
time, the objects were important souvenirs
symbolizing the street. Based on all the
materials, we discussed what the output
should be. After a few debates, we finally
decided to make a double-sided poster
containing a story about Feldbergstrasse
by emphasizing the shapes and textures
of the collected items.

In the front, we embedded our impressions
of the street by scanning the found ob-
jects and the drawings. In the back, we
composed the images of the street as well
as the pictures taken together with Ana.
Additionally, the information about to-
day's workshop and the website address of
the Feldberg zine and the BB2 project
were place at the top. Using three differ-
ent color papers, a total of 50 post-
ers—black and white front and two-color
back—were printed in silkscreen.

Collaboration with Ana was an opportunity—
by being part of someone else's project—to
observe how independent publications are
generated and continued throughout time.
The workshop not only helped us find common
content but also have a chance to present
each others' projects to the readers of
the other culture by sharing the "pages"—
through documenting these experiences in
the Feldberg zine and the publication
of the BB2 project. In this regard, Ana's
workshop was different from the previous
workshop with the University of Arts
Bremen; the former collaboration was about
reciprocally being part of each other's
project to give the content its own life,
while the latter had the collective goal
of creating a single identity for the three
different schools. Though the approaches
of both collaborations were different, both
workshops remained meaningful in terms
of making efforts to overcome disadvan-
tages—limited distribution—of small press.
The two guerilla collaborations, in the
end, were the time to find ways to make
independent publications survive together.

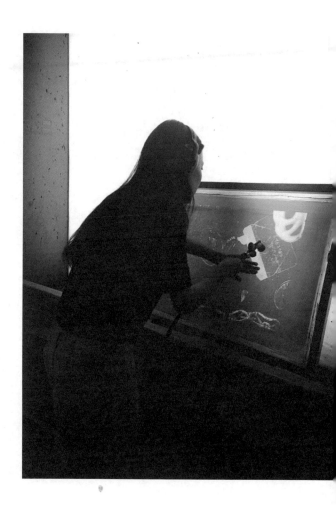

BB-2: Bremen to Basel Workshop

Second publication focuses on collaborations with self publishers.

Paju Typography Institute students directed by
Eunjung Kwak
and Alex Jiyun Lee

Feldberg Self Publishing
Ana Brankovic

Explore your street –
upcoming publication
hyperlocal swiss
journalism.

Workshop participants
Eunjung Kwak
Alex Jiyun Lee
Jinoon Choi
Ruda Jiyeon Lee
Ga Eul Shin
Jiwon Holi Yoon

HUCKEBEIN FELDBERGSTRASSE 72

HYPERLOCAL STREET EXPLORING

LUNCH ILLUSTRATIONS

PHOTOGRAPHY OBJECTS

BOOK STORE VISITS

PRINT SILKSCREEN WORKSHOP POSTER

Working in small groups of people can lea

to nice combinations of subjective visualit

10am 11am 12pm 1pm 5pm 7pm and perceptions of Feldbergstrasse

Feldberg Self Publishing
Ana Brankovic

Explore your street –
upcoming publication
hyperlocal swiss journalism.

Workshop participants
Eunjung Kwak
Alex Jiyun Lee
Jinoon Choi
Ruda Jiyeon Lee
Ga Eul Shin

Since the collaboration was about self-publishing the aim was to have the collected content transformed into a small low budget and self produced print product. A silkscreen workshop poster seemed the best solution to combine photography and found objects into an visual output.

BB-2: Bremen to Basel Workshop

Second publication focuses on collaborations with self publishers.

Paju Typography Institute students directed by Eunjung Kwak and Alex Jinyun Lee pati.kr

BB-2: Bremen to Basel
Workshop

Second publication
focuses on collaborations.
focuses on self publishers.
with self publishers.
...graphy Ins...

...016!

pati.kr
facebook.com/bb2project

...kshop participa...
Eunjung Kwak
Alex Jiyun Lee
Jinoon Choi
Ruda Jiyeon Le...
Ga Eul Shin
Jiwon Holi Y...

...ng K...
Alex Jiy...

FELDBERGSTRASSE

필요와 욕구

독립출판 씬은 우리에게 남은 마지막 땔감 같은 거예요. 다 같이 모여서 불 쬐고 있는 거거든요. 저쪽에서 보면 굉장히 신나 보이지만 사실 저희에게는 추운 곳이에요. 저희가 폐쇄적인 문화를, 그들만의 리그를 가지고 있지만, 기성 출판물 혹은 그것을 찾는 사람을 거부하는 건 아니에요. 또 누군가 이 폐쇄적인 문화에서 이탈했을 때 그들을 상위에서 하위문화로 내려갔다고 판단하는 것도 아니고요. 현재 머물러 있는 2,500여 명이라는 독자를 소중히 보는 것뿐이죠. 때문에 지금의 문화를 의도적으로 확장하거나 더 많은 독자층을 지향하지 않아요.

뭐, 그들만의 리그라고 해서 나쁜 것도 아니니까요. 저 또한 작은 공유로 만족해요. 굳이 이걸 알려서 유명해지고 싶지 않아요. 억지로 확장하면 그만큼 제약이 많거든요. 작위적인 콘텐츠는 무엇이 되든 간에 거부감이 생기는 것 같아요.

어떤 필요가 독립출판을 탄생시킨다고 생각하지 않아요. 독립출판 대부분은 수요도, 필요도, 쓸모도 없어요. 실용적인 용도를 가진 독립출판물은 거의 존재하지 않아요. 때문에 어떠한 필요가 독립출판물을 끌어냈다고 보기는 어려워요. 저의 경우 시작은 무조건 강한 자의 욕구에서 시작된다고 생각

하는 편이에요. 개인이 표현하고자 하는 욕구를 발산하는 하나의 방식으로 독립출판물이 있는 것이지요.

독립출판이라는 이 작은 씬에서 아무리 빛난다 하더라도 독자 수가 100명에서 500명에 머무는 경우가 많기 때문에 끊임없이 대형 출판사에 응모하는 사람들도 있어요. 반면 독립출판은 본인의 특수한 욕구와 특수한 방식이 맞물린다고 생각하는 소수에 의해 생성되고 탄생하는 것이겠죠. 필요가 욕구를 압도하는 책은 단 한 권도 없었던 것 같아요.

독립출판 씬에서 스테디셀러가 성립하기 어려운 까닭은 제작자 입장에서 독립출판물을 프로젝트라 생각해서 그래요. 판매 속도와 무관하게 자신의 기준에서 끝났다는 생각이 들면 더는 재인쇄하지 않는 거죠. 그렇기 때문에 더 많은 요청과 수요가 있음에도 불구하고 판매가 종료되는 책들이 꽤 돼요. 제작자 입장에서는 다음 프로젝트로 건너가는 게 좋으니까요.

누구나 자기 이야기를 하고 싶은 욕구가 있는 것 같아요. 그 욕구가 강한 분들이 더 적극적으로 표현하는 게 아닐까요? 저 또한 『록'셔리』[30]를 통해 대단한 사람이 되거나 유명해지겠다는 야망은 없어요. 다만 지금도 중요하게 생각하는 부분이라면 저 스스로 느끼는 재미라고 할 수 있겠네요. 결국 『록'셔리』도 제가 놀자고 만든 책이에요.

독립출판의 경우 의뢰인이 없죠. 그냥 하는 거예요. 저도 펠트베르크 거리에 대해 작업을 해달라는 요청을 받은 적은 없어요. 하지만 이 작업을 하며 펠트베르크 거리에 있는 상점 주인, 이웃, 기관들과 소통하고 그들에게 직접적인 피드백을 받아요. 제게는 누가 이 책을 읽는지는 별로 중요하지 않아요. 이 프로젝트에 흥미를 갖고 콘텐츠를 제공한 참여자가 더 중요해요.

독립출판물은 계속해서 늘어날 거예요. 사람들은 누구나 창작욕이 있잖아요? 지금까지는 책이 아무나 만들 수 없는 것이었다면 지금은 개인이 원하면 언제든지 펴낼 수 있는 것이 됐어요. 개인이 출판하고 유통한다는 것에 많은 사람이 매력을 느끼는 것 같아요. 모두 오감이 있으니 보고 듣고 싶은 욕구가 있잖아요. 그 욕구를 다 충족하고 싶어 하죠. 다른 독립출판물 만드시는 분도 다 비슷한 생각일 거예요. 어떻게 보면 노출증과 비슷한 것 같아요. 자기 콘텐츠를 보여주고 싶은 욕구. 이게 나한테 왜 재밌는지 말하고 싶고 그걸 공감해 주는 사람들을 만났을 때 기쁘기도 하고요.

저는 강의에 나가면 "2006년에 우린 이런 전시를 했고 그 다음에는 이것을 했고"식의 작가와의 대화는 하지 않아요. 저희가 무엇을 했는지에 대해 얘기하기보다는 무엇을 믿는지에 대해 얘기하죠. 이걸 뭐라고 해야 하나... 우린 지금 지극히 개인적이고 자아도취적인 사회에 살고 있어요. 모두 지나

치게 자신의 얘기만 하고 싶어 해요. 나는 이런 생각을 하고 그렇기 때문에 이것을 하고... 개인이 무슨 생각을 하는지 전 관심없어요. 저는 그 사람의 상담 전문가도, 심리 치료사도 아니에요. 제겐 사회를 위해 개인이 어떤 공헌을 하고 있는지가 더 중요해요. 타인의 경험과 자신의 경험이 본인에게 어떤 측면에서 밀접하게 연관되어 있는지, 그 연관성을 작업으로 어떻게 풀어내는지 알고 싶어요. 내면의 세계에 몰입하는 것이 전부는 아니에요. 만약 "나는... 내겐... 나의..."로 가득 찬 작업 설명을 본다면 전 "충분해!"라고 말하고 싶어요. 모두 삼인칭의 시점에서 '우리'에 대해 더 많이 생각해 볼 필요가 있어요.

　　　책을 수집하는 사람의 입장에서 자주 받는 질문은 "요즘 생산되는 독립출판물도 수집하나요?"예요. 오늘날 출판되는 무수한 책을 모두 파악하기는 어려워요. 책을 생산하는 일은 더 쉬워졌지만, 막상 보면 너무 많은 것들이 뒤섞여 있다는 인상을 받아요. 50년 전에 이미 시도된 것을 반복하는 책을 볼 때면 오늘날 책을 출판하는 젊은이들이 독립출판물의 뿌리에 대해 얼마만큼 이해하고 있는지에 대한 의문이 들죠. 하지만 요즘엔 70년대 아티스트 북에 관심을 두는 젊은 세대 사람들도 많이 접할 수 있어요. 디자인이 전부는 아니에요. 어쩌면 그들은 독립출판의 근원을 찾아가고 있는 걸지도 몰라요.

기술적으로 다른 매체에 비해 난도가 낮다는 점도 무시할 수 없어요. 음악과 영화는 기기와 자본, 기술이 많이 필요하지만 퍼블리싱은 주로 인디자인이라는 하나의 기술로 통일돼 있어요. 본인이 어떻게 학습하는지에 따라 초보자도 충분히 접근할 수 있고, 고정적이고 정적인 지면의 특성상 기술을 따라잡거나 능가할 가능성이 있는 거죠. 특정 독자가 기성작가와 대등하게 붙을 수 있는 면이 분명히 존재하는 거죠. 이렇게 개인의 자본으로 기성 출판을 넘어설 가능성, 일종의 신화가 나올 수 있는 씬이라는 것을 고려하면 치사할 만큼 유리한 매체라는 생각이 드네요.

제가 생각하는 독립출판은 자본으로부터의 독립을 의미하기도 해요. 자본이 없지만 이래라저래라 하는 간섭 없이 완벽한 자유를 누릴 수 있죠.

자본에서 벗어난다는 것이 결국 독립출판물의 독자성을 만드는 것 아닐까요?

Needs and Desires

For us, the independent publishing scene is like the last piece of firewood – we are the people huddling around the fire to warm up. From an outer perspective, it could seem as if we are having fun but in fact, it's a bitterly cold place for us. But because we admit to this "closed culture" and keep our own way of publishing, doesn't mean we deny commercial publications or people who favor them. We also wouldn't consider someone who broke away from this scene as a betrayer switching from subculture to mainstream. We just appreciate the current 2,500 readers who value independent publishing. Therefore, I'm neither aiming to forcefully expand this culture nor to make an effort to increase the number of readers.

It's not necessarily a bad thing to have our own exclusive league. I'm also satisfied with small sharings. I'm not aiming to be famous by promoting these zines. Excessive expansion brings more restrictions. Regardless of the quality, contrived contents draw hostility.

I don't see necessity as the core motive for producing independent publications because they often don't have any demands, necessities, or uses. If you think about it, there are almost no independent books that have practical purposes. So It's hard to say it continues because they are useful. In my case, I tend to think the motivation is triggered by the desire of the one who has power. Independent publishing exists as one of the means to express one's desire.

Because the maximum number of readers usually results in between 100 to 500 – no matter how much limelight you get in this scene – some people still take the challenge of applying to big publishing houses. In this regard, I would say independent publishing is generated by the minorities who believe this peculiar system corresponds to their special needs. Indeed, I've never seen a single book where need overpowers desire.

A reason why steady sellers are not valid in this scene is because people who publish independent publications consider them projects. Regardless of how quickly the books sell, if they think the project is over, there is no chance for reprinting. This is why there are quite a number of terminated books in spite of constant needs and demands – because from a publisher's perspective, it's better to move on.

Every person has a desire to talk about them-selves. But whoever has a stronger desire is the one who expresses more. I also don't have a great ambition to be famous by releasing Rock'xury [30], but what I take to be important is to enjoy the process. In the end, Rock'xury was another way for me to have fun.

When it comes to self-publishing, you don't have any commissioners. You just do it. I've never been commissioned to do a project about Feld-bergstrasse [31]. But instead, I've been communicat-ing and getting direct feedback from shop owners, neighbors and institutions about Feldbergstrasse. In the end, it doesn't matter who reads it. What's im-portant for me is the people who found this project interesting and were willing to provide the contents.

Independent publications will continue to in-crease because every single person has a desire to create something. Who wouldn't? Unlike the past, when producing books was not available for everyone, today books have become feasible ob-jects which anyone can create. I think many people are attracted to the idea of having general control over the publication and distribution. As we react to

our five senses, we all have cravings to see and listen. Everyone wants to fulfill these desires. I think it's the same for those who make independent publications. It's somehow similar to exhibitionism – a desire to expose their contents. We want to let people know why we find something interesting and get pleasure from meeting those who sympathize with the contents.

When I go to lectures, I don't say, "We did this exhibition in 2006, then we did this and that". We don't talk about what we did. Instead, we talk about what we generally believe. How do I say this... we are living in a society which is too individualistic and narcissistic. Everyone wants to talk about themselves. "I was thinking about this and that's why I did this..." I don't care. I am not your therapist or psychologist. What I am interested in is the things that you are contributing to the world. How do you make your experience and my experience into something that's relevant for yourself and how do you develop such experiences into your own work. It's not always about just looking inward. If you read any artists' statements, they are full of "I, I, I...", enough. We all need to see from the third person's perspective and think more about "we" rather than "I".

From a collectors' point of view, we often get a question like "do you also collect independent publications produced nowadays?". It's always difficult to have an overview on the books produced today because there are so many. It's true that books are now more easily produced but when I take a close look, I get a feeling too many elements are mixed together. When I see a book repeating things that were already done 50 years ago, I wonder how much the young publishers of today know about the root of independent publishing. Yet lately, I meet people from the younger generation who are interested in books from the 70s. So it's not all about design, but also going back to the root.

The technical aspect should be underlined as well. Making independent publications are relatively easy to accomplish compared to other mediums. For instance, mediums such as music or film require a lot of equipment, funds and skill. Yet techniques for publishing are generally unified into a single device called "InDesign". The way that someone considers the characteristics of papers – static and fixed – depends on one's educating methods. It's possible enough for beginners to quickly catch up or even do better in terms of skills. In short, the inde-

pendent publishing scene definitely has potential for certain readers to compete against pre-existing publishers. Taking into account this scene, where it's capable of creating a myth – outperforming established publishers with private capital – independent publishing seems to be an advantageous scene which pre-existing publishers might be jealous of.

When I say self-publishing, I also mean self-funded or crowdfunded. The budget is always tight but instead, you can have complete freedom without anyone telling you to do this or that.

Eventually, being free from the capital is what creates the originality of independent publishing. No?

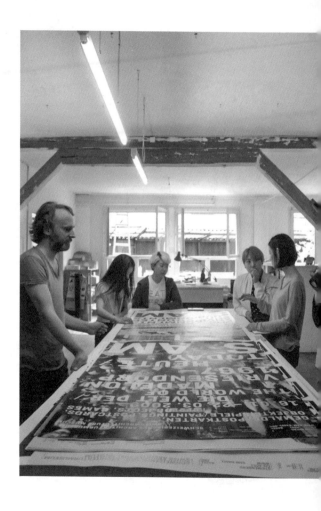

자본과 유통

예술을 하는 사람도 마찬가지겠지만 유통할 수 있는 플랫폼이 없는 곳에서의 생산은 건강할까요?

가끔은 출판을 위해 금전적 지원이 필요할 때도 있어요. 『불투명한 바람』의 경우, 바바라[31]가 매우 마음에 들어 했기 때문에 그녀 스스로 지원금을 찾아 나섰지요.

 스위스의 대규모 출판사를 통해 유통되는 출판물은 정치색이 과해요. 문제는 돈이에요. 거액의 지원금을 받은 출판사는 무료 배포가 가능한 출판물을 만들고, 이러한 출판물은 사람들이 많이 지나다니는 거리에 놓이게 되죠. 돈을 지급하지 않고 누구나 가져갈 수 있는 출판물의 경우 많은 사람이 더 쉽게 접할 수 있기 때문에 그 영향력은 어마어마해요. 출판물에 담겨있는 좌파, 우파적 성향을 암암리에 확산하는 셈이죠. 독립 출판물은 이러한 틈새를 노려 다른 시각을 제공할 수 있다는 점에서 의미가 있죠.

저는 펠트베르크 진의 제작비를 벌기 위해 세 가지 이벤트를 기획했어요. 이벤트의 하나로 파티를 열었는데 술이 이렇게 도움이 될 줄 몰랐죠. 펠트베르크 거리에 위치한 편의점 주인과 친구가 운영하는 바에 부탁해 따로 돈을 지불하지 않고 공간을

빌릴 수 있었어요. 그날 제공된 모든 음료에 1프랑씩을 더해 생긴 이익금을 제작비로 사용했어요.

　　　흔히 '독립'이라는 것은 여러 제반 사항에 구속되지 않고 자유롭게 활동할 수 있는 것을 말하지만, 우리가 독립할 수 없는 결정적인 이유는 돈이 없기 때문이에요. 독립출판을 자기 개성의 발현이라고 한다면 저희는 거리가 멀고, 그냥 돈이 없으니까 독립출판을 한다는 게 더 맞아요. 독립출판이라는 말을 내건 이유는 그래야 관심을 많이 받을 수 있어서예요. 결국 저희는 사업체를 지향하는 것이지 소수 집단으로 개성을 위해 고군분투하는 것은 아니어서 그런 점이 기존의 독립출판과 다른 것 같아요.

　　　제작비를 축소할 수 있는 샘플링 형식의 출판도 눈여겨 볼 필요가 있어요. 예술가 입장에서 충분한 자금을 확보해 책을 출판하는 일은 쉽지 않아요. 샘플링이란, 협업을 통해 책을 출판하는 시스템이에요. 이를테면 누군가가 A4 판형의 책 500부를 출판하고 싶을 때, 50명의 작가에게 협업을 제안할 수 있어요. 제안을 승낙한 작가는 각자 원하는 종이에 원하는 형식의 작업을 500부씩 기고하고 자신이 맡은 분량에 해당하는 비용을 지급하는 방식이에요. 이렇게 나온 결과물을 하나의 책으로 엮어 출판하면 500권을 만드는 데 큰 비용이 들지도 않고 그다지 복잡하지도 않아요. 결과물이 완성되면 기획자는 협업을 도와준 50명의 작가에게 보답으로 책을 한 권씩 보내고 남은 450권의 책을 출판할 수 있게 되는 거죠. 이러한 형태는 과거의 특별한 출판 방법 중 하나예요.

저희는 매년 6개월 단위로 파리에서 진행되는 블레스[32]의 패션쇼를 기록하고 룩북으로 만드는 일을 해요. 모든 룩북은 기존에 출판되는 잡지와 협업하는 형태로 출판하고 있고요. 물론 이를 지속하기 위해선 매번 잡지사를 찾아 먼저 제안을 해야 하죠. 최근엔 '모임 별'[33]이라는 한국 예술인 그룹과 협업하기도 했어요. 이러한 유통 방법은 기존의 방식과 차별을 두는 동시에 패션 외 분야와 만나 가질 수 있는 신선함을 제공해요.

책을 다루거나 제작할 때 접근하는 방법의 하나는 기존의 매체를 이용하는 거예요. 이건 톰 필립스[34]가 만든 책이에요. 그는 19세기에 출간된 윌리엄 말록[35]의 소설책에 자신의 그래픽 이미지를 더해 새로운 작업으로 만들어냈어요. 책 제목도『휴먼 도큐멘트(A Human Document)』라는 본래 제목을 개조해『휴무먼트(A Humument)』라는 새로운 제목의 책을 만들었죠. 가격도 48유로로 기존 서적과 큰 차이가 없어요.

블레스 룩북 재고를 6, 7년간 베를린 창고에 보관해 두었다가 최근에 하나로 묶어 특별 한정판으로 출판했어요. 블레스에서 제작한 열쇠고리로 묶여 있어서 소비자의 취향에 따라 새로운 잡지를 추가하거나 기존의 것을 뺄 수도 있어요. 이러한 형태는 수집 가능한 오브제로써 가치가 있다고 생각해요. 하지만 다양한 출판사를 통해 유통된 룩북을 하나로

묶어 재출판하는 경우 위험성이 크고 그 과정이 까다로워서 이러한 형태의 작업을 다른 출판사에서 받아들이는 경우는 드물어요. 제 출판사를 설립한 것도 이러한 이유 때문이에요. 다른 출판사에서는 엄두도 내지 않을 도전적이고 의미 있는 작업을 하는 거요.

　　물론 아티스트 북을 일반 서점에서 접하긴 어려워요. 그건 과거에도 마찬가지였어요. 소규모 출판사를 가진 사람의 갤러리나 서점을 방문해 작업을 교환했죠. 수익을 창출한다는 목적보다 관계를 형성하려는 의도가 컸어요. 따라서 책을 사는 행위는 작은 네트워크 시장을 통해서 아는 사람들끼리 이루어졌죠.

Capital and Distribution

It would be the same for artists as well, but I wonder if it's healthy to produce something when there's no platform for distribution.

On certain occasions, financial support is necessary. In case the of "An Opaque Wind", Barbara[31] tried to find money for it because she liked the work so much.

I think publications distributed by big publishers in Switzerland have too much political influence. The problem is always money. Big money thrown into publishing houses became the major resource for free print-outs which people can pick up anywhere on the street. These print-outs have enormous power especially when they are free because people can get them more easily. But at the same time, they covertly spread either left-wing or right-wing ideas. Independent publications can be useful in terms of providing different perspectives by filling these niche areas.

In my case, I organized three events to earn money for Feldberg Zine. One of them was a drinking

party. I didn't expect alcohol would help this much. I asked the owner of Feldberg kiosk and my friend who has a bar there, if I could borrow the space for the event so I didn't have to pay. At the party, we just charged one franc more on each drink and that one franc from each person eventually went to my project.

In general, "being independent" refers to the capability of acting for oneself without outside control. For us, the crucial reason that we can't be independent is simply because we have no money. If you say independent publishing is about manifesting one's individuality, that's definitely not the case for us. We consider ourselves as independent publishers mainly because of the tight budgets. The reason why we put up, "Independent publishing" was just because we wanted to get more attention. At the end of the day, we are in pursuit of enterprise rather than being minors struggling for their individuality. Perhaps this is what makes us different from general independent publishers.

In respect to minimizing the production cost, it might be interesting to pay attention to the type of publishing called "Sampling". It's not always easy for artists to have enough money for publishing.

Sampling is like a publishing system driven by having collaborative works. Let's say you want an edition of 500 copies in A4 format, then you make proposals to 50 different artists. The artists who accept the proposals can contribute 500 copies of work on any type of paper. They also agree to take full responsibility for the cost of printing and the paper that corresponds to their portion. If you collect these submissions and bind them into one book, making 500 copies is neither too complex or too expensive. Once the book is complete, you can publish the remaining books of 450 after sending one copy to each artist in gratitude. In the past, this was one of the special ways to publish.

Every six months we document the Bless'[32] fashion show happening in Paris and make it into a lookbook. All the lookbooks we've made are published in existing magazines. Of course in order to continue this, we have to make inquiries every time. Actually, we recently collaborated with a Korean artist group called "Byul"[33]. This type of distribution is a way to escape from ordinary distribution methods and at the same time provides a chance to encounter new areas that do not solely belong to the category of fashion.

One approach you can take in terms of making or dealing with a book is to use already existing materials. This is a book made by Tom Phillips [34]. He took a novel published by William H. Mallockin [35] the 19th century and created a new work by adding his own graphic images. As for the book title, he converted the original title of "A Human Document" into the new title, "A Humument". The price of the book is just 48 Euros which is not more expensive than other hardcover books.

After we collected Bless lookbooks for 6-7 years and kept them in a storage in Berlin, we decided to bind and publish them together as limited editions. We used the keychain made by Bless for binding, so anyone can add a new magazine or take out whatever edition they like. These editions are valued as collectables. Yet if you take this project into another publishing house, they would never accept it. They would say "it's too dangerous or problematic to publish" because this is something that was already published by other publishing houses. That was also why I founded my own publishing house – to publish projects like Bless which is challenging and important to me, yet no one else would dare to publish.

■ Of course it's difficult to find artists' books in normal bookshops. It was the same in the past. People made exchanges within galleries or bookshops owned by small publishers. These exchanges are not made to earn money but rather to create a network. So buying these books was done by the people who knew this network, a small market.

아이 네버 리드

BB2 프로젝트의 한 과정으로 참여한 '아이 네버 리드'는 해마다 열리는 바젤의 아트북페어다. 6월에 열리는 '아트 바젤' 주간에 맞춰 총 3일간 진행된다. 개인과 그룹으로 구성된 100여 개의 다양한 출판사 및 단체들이 참가하며 기성 출판물을 비롯해 엽서와 포스터 등 다양한 인쇄 매체가 전시되고 팔린다.

우리는 브레멘예술대학, 바젤디자인학교, 파주타이포그라피 학교로부터 받은 스무 권의 책을 전시했다. 요리책, 패션잡지, 달력과 같은 인쇄 매체를 포함해, 브레멘예술대학의 출판 동아리 '프레시 프린트' 학생들과 함께 제작한 에코백과 스티커, 그리고 바젤디자인학교 재학생 아나 브랑코빅 워크숍을 통해 만든 가지각색의 포스터를 함께 판매했다. BB2 프로젝트의 설명을 담은 엽서를 사람들에게 나눠주기도 했다.

I Never Read

I Never Read is Basel's annual art book fair which we participated in as part of the BB2 project. The fair is scheduled during the Art Basel week and held for three days. Hundreds of publishers and organizations, which consist of individuals and groups, exhibit in the fair to sell different types of printed matter such as commercial publications, postcards and posters.

BB2 team members displayed twenty books collected from the University of the Arts Bremen, the Basel School of Design and the Paju Typography Institute. These books include experimental prints of cookbooks, fashion papers and calendars, ecobags and stickers created together with Fresh Print, a publication platform of the University of the Arts Bremen and different color-posters produced during the workshop with Ana Brankovic. The postcards describing the BB2 project were distributed for free.

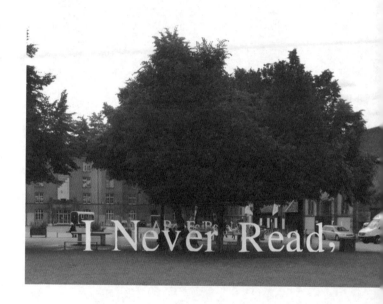

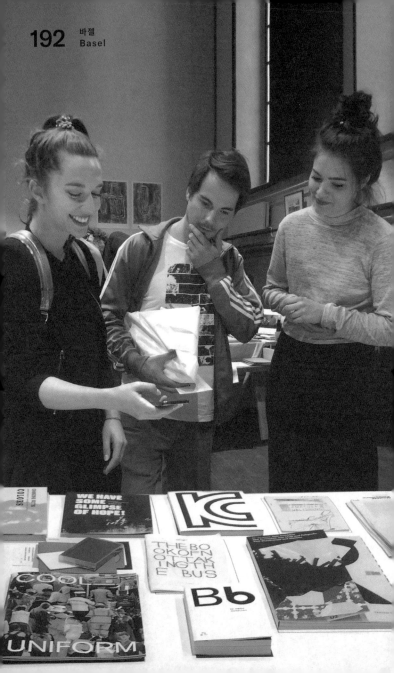

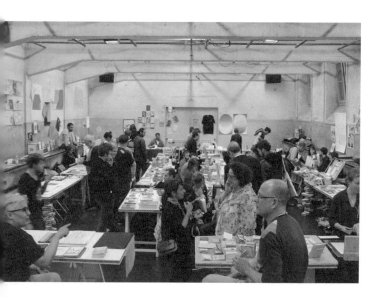

북페어

사전지식이 없는 사람들은 독립출판물이 2009년에 본격적으로 시작됐다고 생각하는데 그건 오해예요. 그 전에도 독립출판물은 많은 디자이너에 의해 존재했지만 유통 가능한 형태로 두각을 나타낸 것이 서점과 페어가 나타나기 시작하면서이죠. 형태가 보이고, 공간이 보이고, 또 사람이 보이면서 가시화된 거죠. 그 전에는 모두 각개전투를 하고 있던 양상이라면, 2008, 2009년부터 눈에 보이기 시작한 거죠.

(언리미티드 에디션의 경우) 주최 측으로서 죄송한 마음이긴 하나 페어의 한도를 넓힐 계획은 없어요. 독립출판 문화나 출판물은 참여자가 80에서 200만원을 투자해가면서 광활한 공간에 부스를 세우고 방문자가 편안히 관람하면서 한두 권의 책을 사거나 사업 이야기를 하거나 상담을 받는 식으로 굴러가는 일반적 페어의 성격으로는 작동 불가능해요. 그렇게 되려면 세 가지의 요소 중 하나라도 성립해야 해요. 주최 측이 부자거나 제작자 또는 방문객이 금전적 여유가 많아야 해요. 저희는 이 세 가지 다 아니거든요. 그러니 페어를 확장하는 건 무리수예요. 어떤 팀은 페어로 인한 수익이 6만원 일수도 있는데 '자 이제 우리 코엑스[36]로 갈 거니 부스당 90만원씩 내세요' 할 수는 없잖아요? 실제로 세계의 모든 예술 페어는 불편하고 사람들로 미어터져요. 그들 역시 상업적인 시설을 빌리지 않거든요.

결국 대중적인 판매가 목적이 아니므로 페어에서의 판매는 중요한 거예요. 다시 말하면, 페어를 참여한다는 것이 영리를 목적으로 하는 것이 아니기 때문에 그날 얼마나 판매하는지는 대단히 중요한 수치인 거예요. 오히려 자본이 목적이었다면 판매량이 중요하지 않을 수 있어요. 얼마만큼 호명이 되었는지, 긍정적인 반응이 있었는지, 이걸로 뭘 할 수 있는지가 사실 상업적인 생각일 수도 있는 거죠.

미스 리드 북 페어에 갔었죠? 이제 인쇄물은 틈새시장으로 자리 잡고 있는 것 같아요. 제가 흥미롭게 보는건 디지털 인쇄가 이렇게 틈새를 공략하고 있지만 한편으로는 사치스럽고 비싸다는 거예요. 그렇지 않나요?

독립출판물 페어도 대형출판사 자회사, 산하 출판사들이 많이 들어가는 것으로 알고 있어요.

15년 전만 해도 전시를 개최하며 때에 따라 저희도 작은 북 페어를 열곤 했어요. 당시엔 몇 안 되는 초기 북 페어 중의 하나였죠. 요즘엔 많은 도시에 다양한 북 페어가 존재하기 때문에 굳이 브레멘에 북 페어를 만들 필요성을 못 느껴요. 어차피 많은 사람을 모을 수 없거든요. 현재는 베를린에서 열리는 미스 리드가 중심이 된 거 같아요. 중요한 만남의 장소이자 교환의 장소가 된 셈이죠.

Book Fair

People without prior knowledge believe independent publications began in earnest in 2009, but this is a misunderstanding. Even before then, independent publishing existed by many designers. It started to become distinguished as a distributable form when the independent bookshops and fairs began to emerge. In other words, it was not exposed as a category until the rise of visible form, space, and people. If independent publishing became noticeable around 2008 or 2009, before then, it was more like constantly having an individual fight to get published.

I feel sorry to say this as a host (of Unlimited Edition), but I'm not planning to expand the fair anymore. The make up of general fairs – where exhibitors invest KRW 800,000 to 2,000,000 to set up a booth in a vast space and visitors engage in consultation, discuss business and buy one or two books while taking a stroll to look around – can never be applied to the culture or the publications of independent publishing. To do so, you need at least one of these three factors: Wealthy hosts, rich exhibitors or financially well-off visitors. We don't have any of

these three. So it is irrational to expand the fair. While some exhibitors would only make KRW 60,000 profit, we can't say "now we decided to have the fair at COEX[36] so please pay KRW 900,000 per booth". In fact, all art fairs around the world are inconvenient and packed with crowds because they also don't rely on commercial facilities.

In the end, because the objective of independent publishing is not to make popular sales; sales at fairs are important. In other words, because people don't participate in a fair to make a profit, the number of books that are sold during the day is significant. If the main purpose was to increase one's capital, the volume of sales may not have been so important. Commercial thoughts could be more related to such ideas as: how many times the book was mentioned, how much positive feedback it elicited or how to develop this book for further use.

You went to "Miss Read", the book fair, right? It seems like prints are becoming almost like a niche place. What I found interesting is... all the digital prints are now going for these niche places but at the same time they are very luxurious and expensive, right?

As far as I know, many subsidiaries and affiliates of big publishers also participate in book fairs.

Almost 15 years ago, we did a little book fair at an exhibition. It was one of the first book fairs. Now there are many book fairs in many cities so it didn't make any sense to participate at the Bremen book fair because you can't have a lot of visitors. Now Miss Read in Berlin seems to be the central thing. It became an important meeting place or exchange place.

공간

출판사 유어마인드[37], 혹은 언리미티드 에디션은 끝없이 변화하는 제 논리나 판단을 바로 투영해 볼 수 있는 도구로써 대단히 적합하고 소중해요.

독립출판 서점은 운영자의 성향이 너무나 직접적으로 드러날 수밖에 없는 공간이에요. 나름 객관적으로 유어마인드 공간의 정의를 내린다면 '남의 집 서재'라고 생각해요. 불편한 공간에서 불편하게 보는 것이 이 문화에 가장 적합한 방법이라고 생각해요. 99.9%의 방문객과 독자는 이미 유어마인드가 뭐 하는 곳이고, 뭐가 모여 있고, 이곳에 가면 무엇이 좋을 것이며 어떤 경험을 할 수 있을지 확신하고 오시는 거거든요.

요새 독립 출판물을 파는 곳을 보면 접근성을 높이기 위해 한쪽에는 커피를 팔고 다른 한쪽에는 독립출판물을 진열하는 독서 카페 같은 공간이 많이 생겼어요. 막연하지만 '홀리데이 아방궁'[38]도 그런 생각을 가지고 시작했어요. 하지만 이런 공간이 생소해서 방문하신 분들에게 독립출판물을 가져다 드리면 어색해 하시더라고요. 그래서 지금은 거의 작업실로 사용하고 있어요. 장기적이지는 않지만 인디자인이나 책제작, 또 '작은 가게 만들기'라는 강의도 하고 있어요. 그 수익으로 생계유지도 할 수 있고요.

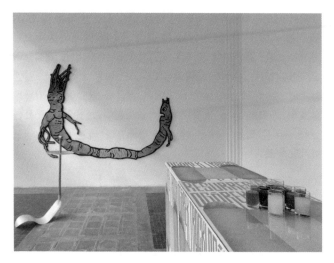

'이 세상을 그만둬라, 다음도 그만두고, 그만두는 것도 그만둬라'는 명언이 있어요. 아무리 완벽한 이념을 가졌다 하더라도 시간이 지나면 자신을 가두는 감옥이 된다는 뜻이에요. 저희는 슬라브스와 타타르스를 운영하며 만족하고 있어요. 처음 이 일을 시작했을 때는 달랑 200유로로 시작했지만 지금은 주요한 미술관으로부터 거액의 지원금을 받아요. 모든 일이 순조롭게 진행되지만 초창기 때만큼 배우는 게 많지 않아요. 형식적으로 책을 만들고, 전시하고, 설치하고, 강의하는 일상이 반복되죠. 지금은 우리가 새롭게 할 수 있는 것이 무엇인지 고민해봐야 하는 시기예요.

그래서 떠오른 아이디어 하나가 바로 피클 주스만 파는 바(bar)를 여는 거예요. 동유럽 사람들은 숙취 해소를 위해 피클 주스를 마셔요. 최근 폴란드에 편의점 느낌의 피클 주스 바를 개점했어요. 인테리어는 '인생은 오이와 같다. 어느 날은 손에, 어느 날엔 항문에 있다' 라는 이집트 속담에서 영감을 받았어요. 피클은 발효의 과정을 통해 만들어져요. 발효한다는 뜻의 영어표현 'go sour'은 썩는다 또는 "정치가 부패했다"라는 의미를 내포하기도 하죠.

 읻다 프로젝트도 사실 '일을 핑계로 같이 놀만한 공간이 있으면 좋겠다'는 순진한 마음에서 시작했어요.

평범한 도서관 같지만, 저희는 아티스트 북만 보관하는 장소가 있어요. 이 공간에서 저희가 유독 신경 쓰는 부분은 기부자별로 책을 보존하는 거예요. 기부자의 유산을 전승하는 차원에서 개인이 추구했던 분류 방식이나 체계를 그대로 유지하기 위해 애쓰고 있어요.

이렇게 수집한 책과 포스터를 더 많은 사람이 보아야 한다는 생각으로 작년에 『도시 속에서』라는 전시를 기획했어요. 예술가들이 공공장소에 규격이 큰 포스터를 걸 수 있었어요. 당시 기자 페네스키[39] 라는 헝가리 예술가에게 책자를 의뢰했고, 그는 작은 신문을 제작해 보내줬어요. 약 3,000부가량을 인쇄해 특정 카페나 전시에 무료 배포해서 큰 홍보 성과를 이뤄내기도 했죠.

책을 읽는 공간을 만든다는 관점에서 환영(hospital-ity)의 개념은 저희에게 매우 중요한 요소예요. 요즘에는 새로운 만남의 장소가 교회나 성당에서 미술관으로 대체되고 있어요. 사회가 점점 세속화되어 갈수록 종교는 퇴보하는 거죠. 테이트 모던을 보세요. 매년 680만명이라는 말도 안 되는 숫자의 인파가 모여들어요. 뉴욕현대미술관의 경우 900만명의 사람들이 방문하죠. 그곳에 가면 마치 기차역에 들어선 것 처럼 사람들이 여기저기 뛰어다녀요. 그 모습을 보며 예술은 교육적이고 유희적인 측면 외에도 관객을 변화시킬 힘이 있어야 한다는 생각이 들었어요. 그리고 예술이 변화의 싹을 틔우기 위해서는 공간이 필요해요.

제가 말하는 변화는 신비한, 형이상학적인, 영적인, 심지어는 종교적인 개념의 변화예요. 만약 여러분이 무언가로부터 변화하거나 초월하고 싶다면 편안히 앉아서 사색할 수 있고 소유했다고 느낄만한 친숙하고 조용한 공간이 있어야 해요. 저도 미술관에 가면 전시를 보러 쉴 새 없이 걸어 다니기만 해요. 공간을 누리기엔 불편한 점이 많아요.

당신도, 저 사람도, 저도 모두 책을 가지고 있어요. 이 사실에는 예외가 없어요. 따라서 공동으로 읽는 행위를 어떻게 활성화할 수 있는지, 함께 읽는다는 것의 의미는 무엇인지를 찾는 게 저희의 다음 목표예요.

Space

The publishing houses Your Mind [37] and Un-limited Edition are very convenient and are precious tools to project my ever-changing logic and/or judgment.

An Independent bookshop is a space where the owner's personality is completely exposed. If I give an objective definition of "Your Mind" in terms of space, it would be a study in someone else's house. Reading uncomfortably in an inconvenient space seems to be the most appropriate way to deal with the culture of independent publishing. 99.9% of visitors and readers come to You Mind with a clear idea of what it is, what is in the place, what the benefits are of going to this place and what experience they can get.

When I look at places selling independent publications, in order to increase the accessibility, many of them borrow from the concept of reading cafes where they sell coffee on one side and display independent publications on the other side. Although quite vague at the time, I also started "Holiday Avangoong" [38] with the same idea. But when

I actually brought the independent books to people, they found it rather awkward because people are still unfamiliar with this type of space. So now I use it mostly as a workplace and occasionally teach people how to use InDesign, make books, and give lectures which I call "making small stores". I make a small income from these activities which help me to make a living.

There is a really nice quote that says, "quit this world, quit the next, and quit quitting". What it basically means is that even the most perfect ideology becomes its own prison at some point.

We are happy with Slavs and Tatars. When we first started, we only had a budget of EUR 200 but now we get huge fundings from major museums. Everything is going very well but we are not learning as much as we used to. We are becoming too formulated. It's always a repetition of making books, exhibitions, installations, then doing lectures. Now it's time for us to think about what else we can do.

One idea is to open a bar that only serves pickle juice because in Eastern Europe people drink pickle juice for hangovers. So we just opened the first one in Poland which is like a kiosk. Then we made a design based on an Egyptian proverb, "Life is

like a cucumber – One day in your hand, one day in your ass." We are looking at pickling as also a form of fermentation. In English, "go sour" means to rot or it can also refer to the rotting of a political situation.

We were also naive when we started the Itta Project. I thought it would be cool to have a place where we can play together under the pretext of having a communal workspace.

It looks like a normal library but it's a place where we only collect artists' books. Our principal concern in this place is to preserve books in different archives according to the donators. We try so that each archive maintains the previous owner's method or structure of collecting books – in a sense to preserve their legacy.

Last year, we did an exhibition called "Inside the City" with an idea that these books could and should be seen by a wider public. Artists were able to hang big posters in public spaces. We asked Géza Perneczky[39], a Hungarian artist, to make a little newspaper for us. Then we printed about 3,000 copies and distributed them in certain cafes and exhibitions for free. This method brought us a great promotional effect.

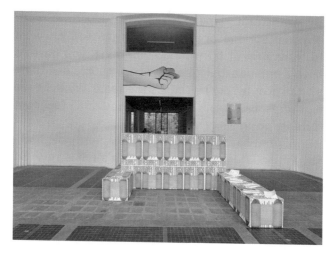

Hospitality is very important in terms of creating a reading space for people. Today, museums have replaced cathedrals and churches – It's kind of a new place for people to congregate. As society gets more secularized, religion steps back. If you look at Tate Modern, 6.8 million people visit every year. It's crazy. MOMA has 9 million people a year. And if you go there, people are running around like a train station. This sight made me think that the role of art is not only to educate and entertain people but also to transform people. And if you want art to transform, you have to create a space.

By "transform", I mean in more of a mystical, meta-physical, spiritual or even religious sense. If you want to transform or transcend something, you have to have a intimate, quiet space where people can think, sit and occupy. For myself it's the same. When I go to museums, I just walk, walk, walk. You don't feel comfortable occupying the space.

You have your book, she has her book, and I have mine. This is an exception – It's not a rule. So our next challenge is to find how we can reactivate this collective act of reading and so find a way to read together.

언리미티드 에디션

2016년 11월 서울에서 열린 '언리미티드 에디션'은 2009년부터 이어진 한국의 아트북페어다. 3일간 진행되는 북 페어를 통해 크고 작은 출판사와 단체, 개인이 한 데 모여 교류하고 책을 비롯한 다양한 물건을 판매한다.

우리는 지난 6월 바젤에서 참가한 아트북페어인 '아이 네버 리드'에 이어 BB2 프로젝트의 마지막 여정으로 '언리미티드 에디션'에 참가했다. 이를 통해 이 책이 출판되기까지의 과정을 소개하고 BB2 프로젝트를 알리고자 했다. 함께했던 세 학교 학생들의 책들과 브레멘에서의 워크숍 결과물, 에코백, 파티 배우미가 만든 물건, BB2 프로젝트의 설명이 담긴 엽서 등을 부스에서 선보이고 판매했다.

Unlimited Edition

Unlimited Edition is the Korean Art Book Fair established in 2009. Every year it opens for three days and in 2016 it was held in November. The fair acts as a forum for individuals and big and small publishers to sell and exchange various printed matter including books.

BB2 team members exhibited in Unlimited Edition as a final program of the BB2 project after participating in Basel's Art Book Fair, I Never Read, in June. The purpose was to introduce the project and to share its process before the actual publication. As a part of this event, we displayed and sold books from three schools, outputs of the Bremen workshop, printed ecobags, handmade products from PaTI students and postcards containing the description of the BB2 project.

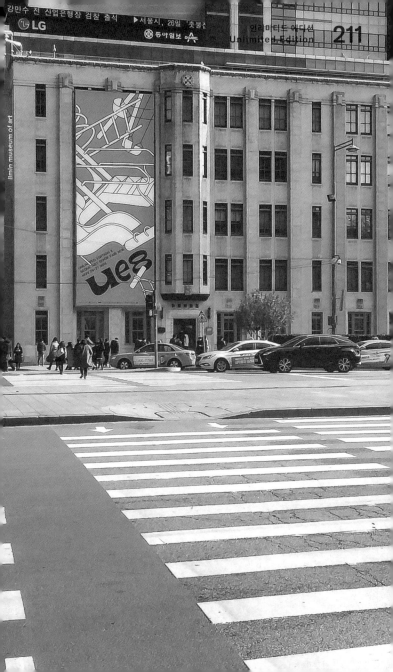

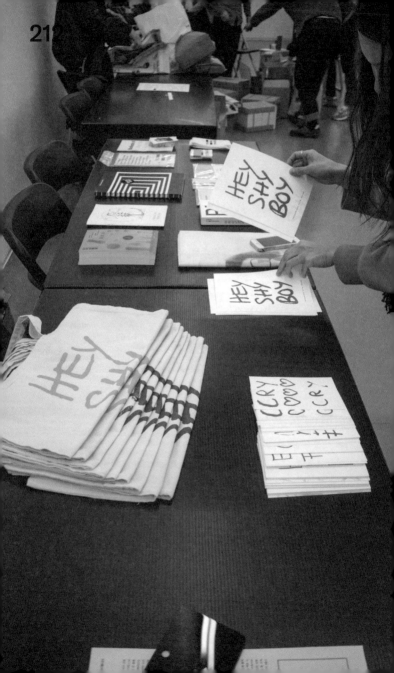

BB-2: Bremen to Base
Workshop

Second publication
focuses on collaborat
with self publishers

Paju Typography Institu
students directed by
Eunjung Kwak
and Alex Jiyun Lee

2016!

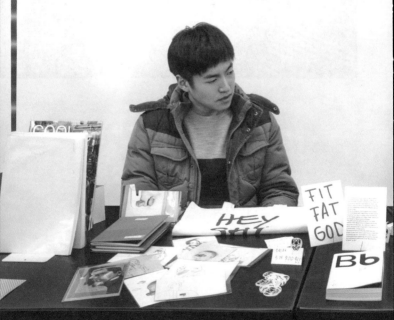

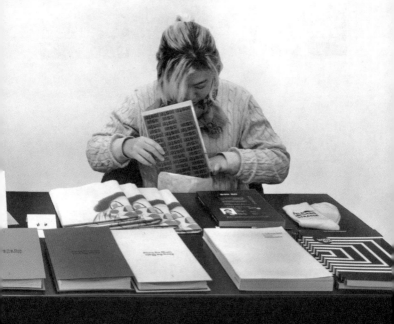

디지털과 아날로그

책은 대체될 수 있는 것이 아니에요. 독립출판을 하는 사람에게 온라인과 오프라인을 구분하고 '왜 책이라는 비효율적인 선택을 하느냐'는 질문은 성립할 수 없어요. 온라인에서는 스크린을 통해 할 수 있는 형태와 방식의 이야기가 있는 것이고 오프라인에서는 지면을 통해 풀 수 있는 얘기가 따로 있는 것이죠.

이를테면 풍경 화가에게 '사진으로 얼마든지 이미지를 보여줄 수 있는데 왜 아직도 그림을 그리세요?'라는 질문은 성립할 수 없는 거죠. 그 작가는 사진의 문법이 아닌 자신만의 문법으로 풍경을 재현하기 때문이에요. 다시 말하면 '블로그에 여행기가 있는데 이것을 왜 굳이 책으로 내야 하나?'라는 질문을 하는 사람에게는 여행기라는 콘텐츠만 중요한 것이지 그 내용을 푸는 방식이 중요한 것이 아니라는 거죠. 각각의 풀이 방법이 가진 차이점을 인식하고 다르게 풀어보겠다는 생각은 안 한다는 거잖아요?

블로그에도 글을 가끔 올리기는 했는데 일회성이 강해서 대충하게 되더라고요. 정리도 덜 되는 것 같고. 무언가를 제대로 만드는 느낌이 들지 않았어요. 책으로 결과물이 나오면 완성했다는 성취감이 들어요.

물론 온라인으로도 무언가를 기록할 수 있지만 저는 이 방법을 신뢰하지 않아요. 쉽게 기록되는 것은 그만큼 쉽게 소멸돼요. 만질 수도 없고 위조될 수도 있고요. 사람들은 실체가 있는 것에 더 관심을 가져요. 오브제, 책, 종이와 같은 것들이 가치가 있는 이유도 만질 수 있기 때문이라고 생각해요. 책에 대한 향수도 무시할 수 없지만 결국은 감각을 통한 기억 때문이죠. 이건 심리학에서 밝혀진 사실이에요. 물론 터치스크린을 통해 기기를 만지기도 하죠. 하지만 스크린을 만지는것과 실물을 만지는 건 완전히 달라요. 온라인은 물리적 측면에서 보면 존재하지 않는 세상이죠.

분류하고 대립을 시킨 뒤 그 대립항에서 비교우위를 만들어야 하고, 그렇지 않으면 박탈감을 느끼는... 꼭 스마트폰을 끌고 와야 책이 빛난다는 생각은 사실 책 자체로 빛날 수 없다는 말 같아요. 전 둘 다 활용할 수 있고 둘 다 제 것이 될 수 있다고 생각해요.

책은 한없이 진지하고 담론을 형성할 수 있는 매체라는 것을 인정한 사람과 그러한 태도가 제게 가장 중요해요.

저는 예전의 사진책처럼 사진만이 중요한 수단으로써 수동적으로 배치되는 시대는 끝났다고 봐요. 디지털 시대의 사진과 책, 그리고 종이가 어떻게 엮일 수 있는지 질문을 해보고 싶은 거죠. 이런 행위를 '매체 실험'이라고 말하고 싶어요.

미디어로서 지금의 현상과 시대에 부응하는 책을 다양한 모양 새로 만들고 싶어요. 실제로 위키피디아에서는 그래픽디자인을 이미지와 텍스트의 조율로 정의하고 있어요. 매체는 너무나 많고 다양한데, 그 속에서 '새로운 형식의 책이란 무엇일까?'를 질문 하는 순간 새로운 책을 만들 가능성이 열리는 것 같아요.

Digital and Analogue

Books can't be replaced. Dividing online and offline categories and asking such questions of "why would you make such an inefficient choice of creating books" wouldn't make any sense to people who make independent publications. Online has its own form and type of content which could be told through the screen whereas offline has its own characters that become more relevant on paper.

It would be the same for the landscape painter for instance. Asking the question "why do you still paint when we can get the photos depicting the same scenery" would be complete nonsense because the painter reinterprets the scenery not with photos but by articulating his own grammar.

For someone asking "why do you have to make a book when there is a series of travelogues on the blog", the main concern is only the contents and not the way of telling the story. It means, the person's not aware of the differences made by different approaches, therefore not concerned about this issue at all, no?

I sometimes post writings on a blog but be
cause of its ephemeral nature, I tend to get
sloppy. It also feels less organized. It doesn't give me
a sense of achievement but books surely do.

Of course we can archive something online
but I don't trust this method. It's there and
then gone. You can't grasp it. You can fake it. People
care more when it is real. I think objects, books, or
papers are still valuable because you can touch them.
It's also about nostalgia, and you actually keep it
in your memory longer when you touch something.
That's a psychological fact. I mean, you touch screens
too, but touching a screen gives a completely differ-
ent experience from touching something real. If you
think about it, the online world is not an existing
thing.

Categorizing, making oppositions, dividing
hierarchy within the oppositions, otherwise
feeling deprived... for me, the idea that a smartphone
is necessary to light up the book sounds as if the
book can't shine by itself. I believe we can take and
use both methods.

For me, people who take the medium of books
seriously and acknowledge its potential, and have
that attitude is most important.

The time when photos were passively located as an absolute means to create a photo book is over. I want to question the relations between images, books and papers to find a way to come together in the digital era. I would like to call this action a "medium experiment". I want a book as a media and would like to create a form corresponding to today's phenomenon, to this period. Wikipedia defines graphic design as a way of composing texts and images. Media environments are quite diverse yet the potential of making a new type of book indeed comes from a simple question – "what can be a new type of book?"

주

1. 두이노 비가(Duineser Elegien, 1923)
 총 10편의 연작시로 구성된 릴케 만년의 대작이다. 1912년 이탈리아
 두이노 성에서 집필을 시작해 1922년 스위스 뮈조트 성에서 완성된
 『두이노 비가』는 출판 이후 전 세계 시인들에게 큰 영향을 끼쳤다. '비
 가'는 희랍에서 '죽음의 노래'를 의미한다.

2. 라이너 마리아 릴케(Rainer Maria Rilke, 1875-1926)
 프라하 출신의 오스트리아 시인이자 작가. 독어권에서 가장 높이 평가
 받는 문학가 중 한 명으로 삶의 본질, 사랑, 죽음과 같은 주제를 다루
 었다. 주요 저서로 『말테의 수기(Die Aufzeichnungen Des Malte
 Laurids Brigge)』, 『두이노 비가(Duineser Elegien)』, 『오르페우스
 에게 부치는 소네트(Sonnets to Orpheus)』가 있다.

3. 르네 데카르트(René Descartes, 1596-1650)
 프랑스 물리학자로 근대철학의 아버지, 해석기하학의 창시자로 불린다.
 합리론의 대표주자이며 대표 저서 『방법서설』에서 '나는 생각한다. 고
 로 존재한다'는 계몽사상의 '자율적이고 합리적인 주체'를 처음 확립한
 것으로 유명하다.

4. 트리스 보나미셸(Tris Vonna-Michell, 1982-)
 서사 형식의 구술 퍼포먼스와 경험담, 사진, 기념품을 이용한 설치 작업
 으로 알려진 영국 출신 예술가. 2005년 스코틀랜드에 위치한 글래
 스고예술학교(Glasgow School of Art)에서 학사학위를 받은 후,
 프랑크푸르트 슈테델슐레예술대학(Städelschule Frankfurt am
 main)을 졸업했다. 2014년 터너상(Turner Prize) 후보자이기도
 하다.

5. 슬라브스와 타타르스(Slavs and Tatars)
베를린 장벽과 만리장성 사이 지역을 가리키는 유라시아를 소재로 작업하는 작가 그룹. 전시, 책, 강연 퍼포먼스에 주안점을 두고 있다.

6. 디터 로스(Dieter Roth, 1920-1998)
아티스트 북, 정기간행물, 조각, 버려진 재료를 이용한 설치 작업으로 유명한 스위스 예술가. 독일 하노버에서 태어나 스위스 바젤에서 생을 마감했지만 국적은 아이슬란드로 알려져 있다. 베른, 코펜하겐, 레이캬비크를 전전하며 회화, 판화, 영상, 조각, 설치를 비롯해 그래픽 디자인과 작곡, 연주에 이르기까지 다양한 매체를 넘나들며 작업했다.

7. 아마존닷컴(Amazon.com, Inc)
세계 최대의 온라인 쇼핑 중개자로 시애틀에 본사를 두고 있는 국제 전자 상업 회사다.

8. 화폐(Money, 2016)
나라별 화폐 이미지를 모은 책. 취리히에 기반을 둔 디자이너 그룹, 타니아 프릴(Tania Prill), 알베르토 비첼리(Alberto Vieceli), 세바스티앙 크레머스(Sebastian Cremers)가 2016년 출간했다.

9. 『GGG 1777-1914: 바젤 사람의 거울에 비친 도시 역사「사회를 위한 선과 공익」』(Basler Stadtgeschichte im Spiegel der「Gesellschaft für das Gute und Gemeinnützige」), 2015
사라 제너(Sarah Janner)가 쓴 책. 사회 공익 협회로 출발한 'GGG'가 능력을 인정받아 바젤시를 자치하게 된 역사적인 내용을 담고 있다. 클라우디아바젤(Claudiabasel)이 디자인한 이 책은, 2015년 '가장 아름다운 스위스 책'에 선정되었다.

10. 탈리스만(Talisman)
신성한 힘이 있거나 행운을 가져다준다고 여겨지는 물건. 보통 이름이 새겨진 반지 또는 돌의 형태다.

11. **팀 울리히(Timm Ulrichs, 1940 -)**
 독일의 개념, 행위 예술가. 조각, 설치, 퍼포먼스, 비디오, 사진, 구성시
 와 같은 다양한 예술 분야와 스타일의 작업을 한다.

12. **노라 슐츠(Nora Schultz, 1975 -)**
 고고학, 인류학, 언어학의 방법론적 기술을 이용하는 독일의 설치작업
 예술가. 프랑크푸르트 슈테델슐레예술대학(Städelschule Frank-
 furt am main)과 밀턴에버리미술대학(Milton Avery Graduate
 School of the Arts, Bard College)에서 공부했다.

13. **미하엘 보이틀러(Michael Beutler, 1976 -)**
 덴마크 출생으로 글래스고예술학교(Glasgow School of Art)와
 프랑크푸르트 슈테델슐레예술대학(Städelschule Frankfurt am
 main)에서 공부를 마치고 현재 베를린에서 활동하고 있다. 주어진
 공간 안에서 물질의 제조 과정과 구조적인 특성을 개념화하는 설치
 작업을 주로 한다.

14. **윌리엄 코플리(William Copley, 1919 - 1996)**
 'CPLY'라고도 알려진 그는 미국 출신의 화가, 작가, 수집가, 예술 사업가
 이자 후원자다. 유럽의 초현실주의와 미국의 팝아트를 연결하는 반인습
 주의적 작업을 선보이며 전후 미술의 저명인사로 자리 잡았다.

15. **만 레이(Man Ray, 1890 - 1976)**
 미국 출신 시각 예술가로 사진, 페인팅, 설치, 영상 등의 작업을 했다.
 1921년 프랑스로 거주지를 옮긴 뒤 다다이즘과 초현실주의 운동에
 참여했다. 포토그램의 일환인 레이요그래프 방법을 미학적으로 사용한
 최초의 인물이기도 하다.

16. **마르셀 뒤샹(Marcel Duchamp, 1887 - 1968)**
 프랑스 전위예술가. 피카소와 함께 현대미술에 가장 큰 영향력을 끼친
 예술가 중 한 명으로 손꼽힌다. 미국으로 망명한 뒤 뉴욕에서 주로 활동

했다. 다다이즘, 초현실주의, 개념미술의 영향을 받은 그의 작품은 1차 세계대전 이후 미술의 발전에 많은 영향을 주었다. 주요 작품으로는 『계단을 내려오는 누드 넘버 2(Nude Descending a Staircase, No. 2)』, 『샘(Fontaine)』, 『그녀의 독신자들에 의해 발가벗겨진 신부, 조차도(The Bride Stripped Bare By Her Bachelors, Even)』, 『주어진 것(Étant donnés)』등이 있다.

17. 로버트 라우센버그(Robert Rauschenberg, 1925-2008)
미국 화가이자 시각예술가. 다다이즘을 새롭게 부활시킨 네오다다이즘의 선구자이기도 하다. 초기엔 추상표현주의의 영향을 받은 단색회화를 주로 그렸으나 50년대 중반 이후 평면에 오브제를 결합한 콤바인 페인팅(Combine Painting)을 제작하며 전통회화의 경계를 무너뜨렸다. 그의 초기작은 팝아트에 영향을 끼쳤다고도 평가받는다.

18. 중력에 대항하는 야생(Wild against Gravity, 2012)
2011년 모던 아트 옥스퍼드(Modern Art Oxford)와 아스펜미술관(Aspen Art Museum)에서 개최된 양혜규의 전시를 기록한 카탈로그. 마누엘 레더(Manuel Raeder)가 디자인했다.

19. 샤르자 비엔날레(Sharjah Biennial)
아랍에미리트의 도시, 샤르자에서 2년마다 열리는 현대미술작품 전시 행사. 샤르자 문화 정보부(Sharjah Department of Culture and Information)가 1993년 처음 개최했다.

20. 양혜규(Haegue Yang, 1971-)
베를린과 서울을 오가며 작업하는 한국 출생 예술가. 일상에서 흔히 접할 수 있는 가정용품의 기능을 재해석한다. 추상적인 이야기를 통해 감각적 경험을 제공하는 것 또한 그녀 작업의 특징이다.

21. 게릴라 아트 액션 그룹(Guerilla Art Action Group, GAAG, 1969-1976)

존 헨드릭스(Jon Hendricks)와 진 토치(Jean Toche)가 결성한 예술 단체. 도발적인 예술 행위를 통해 문화 기관과 정치 권력자에게 윤리적 경각심을 심어주는 것을 목표로 했다.

22. 해프닝(Happening)
 미술, 음악, 연극에서 예술가와 관객 사이에 우발적이고 유희적인 행위를 연출하여 관객을 예술 활동 속으로 끌어들이려는 표현 방식.

23. 록펠러 가문(Rockefeller family)
 미국 기업, 정치, 은행의 중심에 있는 가문. 19세기 말에서 20세기 초, 스텐다드 오일(Standard Oil) 회사를 운영하여 막대한 부를 축적했다. 세계 3대 부자로 손꼽히며 오늘날에도 많은 영향력을 행사하고 있다.

24. 마리아나 카스티요 데바(Mariana Castillo Deball, 1975 -)
 멕시코 출생의 예술가. 멕시코시티에 위치한 멕시코 국립자치대학교 (Universidad Nacional Autónoma de México)와 마스트리흐트 의 얀 반 에이크 아카데미(Jan Van Eyck Academie)에서 공부했다. 현재 베를린에 살고 있다.

25. 카에타노 벨로조(Caetano Veloso, 1942 -)
 브라질 출신 작곡가, 가수, 기타리스트, 작가이자 정치 운동가. 60년대 초 트로피칼리아 운동에 참여하며 이름을 알리게 되었다.

26. 질베르토 질(Gilberto Gil, 1942 -)
 브라질 출신 가수, 기타리스트이자 작곡가. 정치에 헌신했으며 음악적 혁신가로 알려져 있다.

27. 갈 코스타(Gal Costa, 1945 -)
 브라질을 대표하는 여가수. 카에타노 벨로조와 함께 트로피칼리아 운동에 참여한 후 영국으로 망명했다.

28. 시네마 노보(Cinema Novo)
 사회평등과 주지주의를 강조한 6, 70년대 브라질 영화 운동. 브라질
 공식 언어인 포르투갈어로 '새로운 영화'를 의미한다.

29. 글라우버 로차(Glauber Rocha, 1939-1981)
 브라질 출신 영화감독, 연기자, 시나리오 작가. 시네마 노보의 핵심
 인물이자 브라질 영화계의 거장이다. 그가 감독한 『검은 신 하얀 악마
 (Deus e o Diabo na Terra do Sol, 1964)』와 『고뇌하는 땅(Terra
 em Transe, 1967)』은 브라질 영화 역사상 가장 영향력 있는 작품
 으로 꼽힌다.

30. 록'셔리(Rock'xury, 2012-)
 2012년부터 발행된 정기간행물. "돈이 많지 않은 사람들도 약간의 위
 안과 우쭐함을 느끼는 동시에 휴식을 얻을 수 있는" 코미디 잡지다.

31. 바바라 빈(Barbara Wien, 1953-)
 독일의 아티스트 북 수집가, 출판인 겸 미술관 운영자.

32. 블레스(Bless)
 베를린과 파리에 지점을 둔 패션 브랜드. '패션 산업'이라는 정형화된
 틀에서 벗어나 옷을 만드는 행위와 그 경계를 디자인과 예술을 통해
 보여주고 있다.

33. 모임 별(Byul.org)
 예술가, 디자이너, 음악가, 프로그래머로 구성된 단체. 브랜딩, 디자인
 및 소프트웨어 개발에 중점을 두고 활동한다.

34. 톰 필립스(Tom Phillips, 1937-)
 영국 출신 화가, 판화가, 콜라주 작가. 현재 런던에서 활동하고 있다.

35. 윌리엄 말록(William H. Mallock, 1849-1923)
 영국의 소설가 겸 경제학 작가.

36. 코엑스(COEX)
 한국 최대의 협약 및 전시 센터. 서울 강남구에 있다.

37. 유어마인드(Your Mind)
 국내외의 소규모 출판물, 독립출판물을 소개 및 판매하는 서점. 2009년
 부터 이로와 모모미가 운영하고 있다.

38. 홀리데이 아방궁(Holiday Avangoong)
 1인 독립잡지 『더쿠』의 편집자가 2015년 설립한 책다방.

39. 기자 페네스키(Géza Perneczky, 1936-)
 헝가리 출신의 미술학자, 작가, 시각 예술가, 큐레이터이자 교육자.

Foot Note

1. Duineser Elegien, 1923
 Collection of 10 elegies written by Rainer Maria Rilke in the latter years. He began writing in 1912 at Duino castle of Italy and completed in 1922 while staying at Château de Muzot of Switzerland. Duineser Elegien had significant influence on poets around the world since its publication. "Elegien" in Greek means "song of death".

2. Rainer Maria Rilke, 1875-1926
 Austrian poet and author born in Prague. He is considered one of the most significant writers especially in German-speaking regions. Many writings are concerned with themes such as the nature of life, love and death. His major works include "The Notebooks of Malte Laurids Brigge", "Duineser Elegien", and "Sonnets to Orpheus".

3. René Descartes, 1596-1650
 French physicist, also often called father of modern philosophy and founder of analytic geometry. He is a pioneer of rationalism and famous for establishing the foundational principle of "emancipated being equipped with autonomous reason" in the philosophy of enlightenment represented by the phrase, "I think, therefore I am" in Discourse on the Method.

4. Tris Vonna-Michell, 1982-
 British artist who performs narratives and constructs installations by layering personal stories, photographs and mementos. He graduated from the Glasgow School of Art

in 2005, then continued his studies at the Städelschule, Frankfurt am Main. He was also announced as a nominee for the Turner Prize 2014.

5. Slavs and Tatars
An art collective whose motive is derived from an area east of the former Berlin Wall and west of the Great Wall of China known as Eurasia. The collective's practice is based on three activities: exhibitions, books and lecture-performances.

6. Dieter Roth, 1920 - 1998
Swiss artist best known for artist books, periodicals, sculptures, and found materials. He was born in Hanover, Germany and ended his life in Basel, Switzerland but was a national of Iceland. He spent his life in several places including Bern, Copenhagen, and Reykjavik while working on diverse mediums such as drawing, printmaking, film, sculpture, installation, graphic design, composing and playing music.

7. Money, 2016
Book featuring images of different regional banknotes published together with Tania Prill, Alberto Vieceli, and Sebastian Cremers, a design group based in Zurich.

8. Amazon.com, Inc.
The largest global electronic commerce company which has its headquarters based in Seattle.

9. GGG 1777 - 1914 Basler Stadtgeschichte im Spiegel der "Gesellschaft für das Gute und Gemeinnützige", 2015
Written by Sarah Janner. The book contains historical information about the association called GGG who became the established institution that governed the city of Basel.

Book design was done by Claudia Basel and was later selected as one of the Most Beautiful Swiss Books 2015.

10. Talisman
An object, typically an inscribed ring or stone, that is believed to own magic powers and to bring good luck.

11. Timm Ulrichs, 1940 -
German conceptual and action artist. Avoiding any fixed style he works across a wide range of mediums including sculpture, installations, performance art, video, photography, concrete poetry.

12. Nora Schultz, 1975 -
German artist who creates sculptural installations involving methods of archaeology, anthropology, and linguistics. She studied in Städelschule Frankfurt am main and Milton Avery Graduate School of the Arts, Bard College.

13. Michael Beutler, 1976 -
Danish artist. He studied in Glasgow School of Art and Städelschule Frankfurt am main, and currently works in Berlin. His work is centered in conceptualizing the properties of various fabrication processes and material structures in relation to the given architectonic arrangement.

14. William Copley, 1919 - 1996
American painter, writer, collector, art entrepreneur as well as patron; he was also known as "CPLY". Established himself as a personage of post-war painting by presenting iconoclastic works that link European Surrealism and American Pop Art.

15. Man Ray, 1890 - 1976
 American visual artist known for his photography, painting, installation, and film. After moving to France in 1921, he contributed to Dada and Surrealist movements. He was also the first person to use the type of photogram called rayograph as an aesthetic mean.

16. Marcel Duchamp, 1887 - 1968
 French avant-garde artist. Widely recognized, along with Pablo Picasso, as one of most influential artists of modern art. Since emigrating to the United States, he mainly worked in New York. Influenced by Dadaism, surrealism, and conceptual art, his works wielded enormous impact on the art scene after WWI. His most notable works include "No. 2 (Nude Descending a Staircase, No. 2)", "Fountain", "The Bride Stripped Bare by Her Bachelors, Even", and "Étant donnés".

17. Robert Rauschenberg, 1925 - 2008
 American painter and graphic artist. He was a pioneer of Neo Dada which to some extent, revived the earlier concept of Dada. In the earlier period, his works were centered around monochrome paintings under the influence of abstract expressionism but from the mid-50s, he broke the boundaries of traditional painting by integrating objects into a flat surface, from which he coined the term Combines. His early works were later considered to anticipate the Pop Art movement.

18. Wild Against Gravity, 2012
 Catalogue documenting Haegue Yang's exhibition held in Modern Art Oxford and Aspen Art Museum in 2011. The book was designed by Manuel Raeder.

19. Haegue Yang, 1971 -
 South Korean artist working in Berlin and Seoul. Her work
 concentrates on liberating the functional context of daily
 household items. The uniqueness of her work offers sen-
 sory experiences through abstract narratives.

20. Sharjah Biennial
 Bi-annual contemporary art happening taking place in the
 city of Sharjah, United Arab Emirates(UAE). Initially orga-
 nized in 1993 by the Sharjah Department of Culture and
 Information.

21. Guerrilla Art Action Group (GAAG), 1969 - 1976
 Artist group formed by Jon Hendricks and Jean Toche. Their
 aim was to force cultural institutions and political leaders
 to take a moral stand on U.S. politics, through provocative
 actions.

22. Happening
 Partially improvised or spontaneous piece of artistic perfor-
 mance, typically involving audience participation.

23. Rockefeller family
 American industrial, political, and banking family that
 made one of the world's largest fortunes in the late 19th
 and early 20th centuries by running Standard Oil company.
 They are considered one of the top three richest families
 who still remain significantly influential.

24. Mariana Castillo Deball, 1975 -
 Mexican artist who studied at the Universidad Nacional
 Autónoma de México, Mexico City and the Jan Van Eyck
 Academie in Maastricht. She is currently based in Berlin.

25. Caetano Veloso, 1942-
Brazilian composer, singer, guitar player, songwriter, and political activist. He first became known for the participation in the Tropicália movement from the early 60s.

26. Gilberto Gil, 1942-
Brazilian singer, guitarist and writer. Known both for his political commitment and musical innovation.

27. Gal Costa, 1945-
Legendary Brazilian female singer. Joined the Tropicália movement along with Caetano Veloso and later was temporarily exiled to England.

28. Glauber Rocha, 1939-1981
Brazilian film director, actor, and screenwriter. A key figure of Cinema Novo and master director of Brazilian cinema. His movies "Deus e o Diabo na Terra do Sol, 1964" and "Terra em Transe 1967" are viewed as the most influential films in Brazilian cinema history.

29. Cinema Novo
Brazilian cinematic movement in the 60s and 70s. Noted for its emphasis on social equality and intellectualism. In Portuguese, the official language of Brazil, it means "a new film".

30. Rock'xury, 2012
Periodical published from 2012. A comical "zine provides a bit of comfort while making you feel flattered and relieved even for those who live from hand to mouth".

31. Barbara Wien, 1953 -
German artist book collector, publisher, and "Barbara Wien" gallerist.

32. Bless
An interdisciplinary fashion brand based in Berlin and Paris. Their work stays on the borders of fashion and design and challenge the meaning of producing clothing in the context of the fashion industry.

33. Byul.org
Art collective consisting of artists, designers, musicians, and programmers. Their activities are centered in branding, design, and software development.

34. Tom Phillips, 1937 -
English painter, printmaker, and collagist. Currently works in London.

35. William H. Mallock, 1849 - 1923
English novelist and economics writer.

36. COEX, Convention & Exhibition
South Korea's largest convention and exhibition center located in Gangnam-gu district, Seoul.

37. Your Mind
Bookstore that sells and introduces domestic and international independent publications. It was founded in 2009 and run by Iro and Momomi.

38. Holiday Avangoong
Book café opened by the editor of The Kooh.

39. Géza Perneczky, 1936 -
Hungarian art historian, writer, visual artist, curator, and educator.

지은이

곽은정

독일 함부르크의 Creative Studio 'I like Birds'에서 활동했다. 스위스 취리히 예술대학에서 교환학기를 보냈고 독일 브레멘예술대학에서 학·석사 통합과정으로 졸업했다. 『BB: 바젤에서 바우하우스까지』의 공동 저자이다.

신가을

그림책을 통해 어린이와 함께하는 미술 활동, 게임과 애니메이션에 관심이 있다. 파주타이포그라피학교 재학 중 유럽에 가고 싶어서 BB2 프로젝트에 참여했고 지원 동기 이상으로 많은 것을 배웠다.

알렉스

로드 아일랜드 스쿨 오브 디자인에서 학부를 졸업하고 파주타이포그라피학교 더배곳 과정을 마쳤다. 이후 바젤디자인학교에서 석사학위를 수료했다. 『BB: 바젤에서 바우하우스까지』의 공동 저자이자 편집을 맡았다.

이지연

추계예술대학교 미술학부 판화과를 졸업했다. 퍼포먼스 및 설치 작업 등을 하던 중 디자인 감각을 기르고자 파주타이포그라피학교 더배곳에 진학했다. 예술과 디자인 사이에서의 독립출판물 작동방식에 흥미를 갖고 있다.

Author

Kwak Eunjung

She worked as a freelancer designer in a creative studio "I like Birds" in Hamburg, Germany. She spent an exchange semester in University of the Arts Zurich, Switzerland, and graduated from the University of the Arts Bremen with the combined degree of Bachelor and Master. She participated as an author in the book, "BB: From Basel to Bauhaus".

Lee Alex

She completed her Bachelor's degree at the Rhode Island School of Design and did a post-graduate program at the Paju Typography Institute. She then completed a Master's degree at the Basel School of Design. She participated as an author and editor of "BB: From Basel to Bauhaus".

Lee Ji-yeon

Completed her Bachelor's degree in printmaking at Chugye University for the Arts. While working on performance and installation projects, she started a post-graduate program at the Paju Typography Institute to further her designing skills. She is interested in the operational method of independent publications between art and design.

Shin Ga-eul

Currently attending the Paju Typography Institute. She is interested in picture books, art activities with children, games, and animations. She participated in the BB2 project because she wanted to go to Europe, and she is learning much more than she anticipated at the time of application.

이 도서의 국립중앙도서관 출판예정도서목록(CIP)은 서지정보유통지원시스템 홈페이지
(http://seoji.nl.go.kr)와 국가자료공동목록시스템(http://www.nl.go.kr/kolisnet)에서
이용하실 수 있습니다. (CIP제어번호 : CIP2017013402)

길위의 멋짓
BB2: 브레멘에서 바젤까지

지은이
곽은정, 신가을, 알렉스, 이지연

사진
곽은정, 신가을, 알렉스, 윤지원
이지연, 최진훈

멋지음
곽은정, 알렉스

기획
곽은정, eunjung.kwak@me.com
알렉스, alexjiyunlee@gmail.com

글꼴
산돌고딕 Neo1
윤명조 200
GT America (Grilli Type)
Pica 10 Pitch

종이 (두성종이)
루나 미니122 120g
문켄퓨어 90g
스페셜리티즈305 315g

펴낸날
2017년 8월 30일

펴낸이
강대인

펴낸곳
파주타이포그라피교육 협동조합
등록 2014년 8월 14일
제406-2014-000073호
우10881 경기도 파주시 회동길 330
전화 070-8988-5610/4
팩스 0303-0949-5610
info@pati.kr
www.pati.kr

ISBN
979-11-88164-02-8
(02650)

가격
20,000원

Arts Council Korea

이 책은 한국문화예술위원회의 문예진흥
기금을 보조받아 발간되었습니다.

Design on the Road
BB2: From Bremen to Basel

Author

Kwak Eunjung
Lee Alex
Lee Ji-yeon
Shin Ga-eul

Photography

Choi Jin-hoon
Kwak Eunjung
Lee Alex
Lee Ji-yeon
Shin Ga-eul
Yoon Ji-won

Design

Kwak Eunjung
Lee Alex

Art Direction

Kwak Eunjung
 eunjung.kwak@me.com
Lee Alex
 alexjiyunlee@gmail.com

Typeface

GT America (Grilli Type)
Pica 10 Pitch
Sandoll Gothic Neo 1
Yoon Myungjo 200

Paper (Doosung Paper)

Lunar Mini 122 120g
Munken Pure 90g
Specialities 305 315g

First Published

30 August 2017

Publisher

Kang Daein

Published by

Paju Typography Institute
Cooperative
Registered on 4th Aug 2014
Registration No.
406-2014-000073
330 Hoedong-gil, Paju bookcity,
Gyeonggi-do, 10881 South Korea
Tel +82 70-8998-5610/4
Fax +82 303-0949-5610
info@pati.kr
www.pati.kr

ISBN

979-11-88164-02-8
(02650)

Price

20,000 Won

Wednesday morning at
10 o'clock ... guests from
Corea with a big interest
in artist's books ...
... a pleasure to look at
books, to talk about ideas.
Nice to have this contact
via tyk ...
Come again,
 very welcome and
 thank you
 Bettina Buch,
Centre for Artists' Publication,
 Bremen, 8.6.2016

ALL
WOW !
BYE

Thank you all for
this inspiring
exchange.

I hope we meet
again.

Fresh Prints, HfK Bremen
10. 6. 2016

Thanks nana

Long live. Long live!

Death to Death to

Glaws and Tatars
12 VI 2016

Thanks to Lee
Alex Jiyeon Lee
& Jihoon Choi
for visit and
wonderful
Korean Stamps
gift !

D. [signature]
17. june
2016